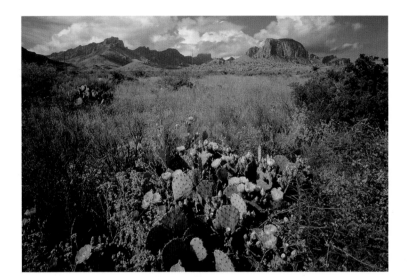

TEXAS

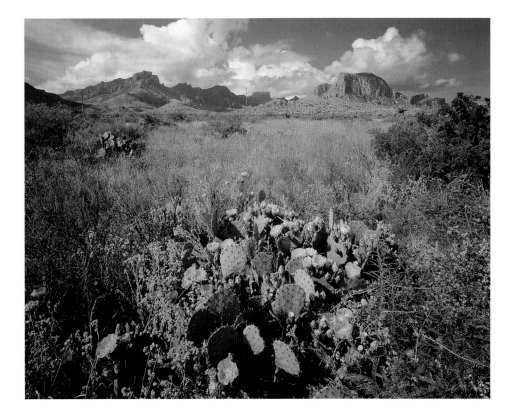

WHITECAP BOOKS
VANCOUVER / TORONTO / NEW YORK

The information in this book is true and complete to the best of our knowledge.
All recommendations are made without guarantee on the part of the author or
Whitecap Books Ltd. The author and publisher disclaim any liability in connec-
tion with the use of this information. For additional information please contact
Whitecap Books Ltd., 351 Lynn Avenue, North Vancouver, BC V7J 2C4.

Edited by Elizabeth McLean
Proofread by Lisa Collins
Photoediting and text by Tanya Lloyd
Cover and interior design by Steve Penner

Printed and bound in Canada

Canadian Cataloguing in Publication Data

Lloyd, Tanya, 1973–

 Texas

 ISBN 1-55110-949-2

 1. Texas—Pictorial works. I. Title.
F387.L54 1999 976.4'063'0222 C99-910829-8

The publisher acknowledges the support of the Canada Council and the
Cultural Services Branch of the Government of British Columbia in making this
publication possible. We acknowledge the financial support of the Government
of Canada through the Book Publishing Industry Development Program for our
publishing activities.

For more information on the America Series and other Whitecap Books
titles, please visit our web site at www.whitecap.ca.

Welcome to Texas! Here, every town has a claim to fame and nothing is done on a small scale. From Austin's state capitol, the largest domed capitol in the country, to the legendary Alamo, where 19th-century defenders fought to their deaths against Mexican attackers, the state offers something to capture everyone's attention. In these pages, you'll find yourself swept up on a vivid photographic tour of the most fascinating places the Lone Star State has to offer.

This is the land of the Wild West, and visitors wandering through the Stockyards National Historic District in Fort Worth discover a time in the 1800s when cattle outnumbered people in Texas nine to one. And a drive through the state's Panhandle region suggests some things haven't changed—agriculture continues to thrive here. In fact, farms and ranches make up an astounding 80 percent of the state.

If cowboy boots aren't your style, try a space suit on for size. You can't get more high tech than NASA's Lyndon B. Johnson Space Center near Houston. Here, you can take a close-up look at moon rocks, or glimpse the activities on board a shuttle. From astronaut training to mission control, you'll discover what it feels like to blast off into space.

Each community or region has something unique to offer. You can catch a glimpse of the turn of the century at Dallas's Old City Park Historic Village, sunbathe in Corpus Christi, gaze up at the sheer cliff face of El Capitan in the Guadalupe Mountains, or try to spot an alligator at Anahuac. At every stop, you'll find something new to experience, and a warm welcome. The state's name is derived from the Native word *Tejas,* meaning "friendship," and people in Texas live up to their reputation.

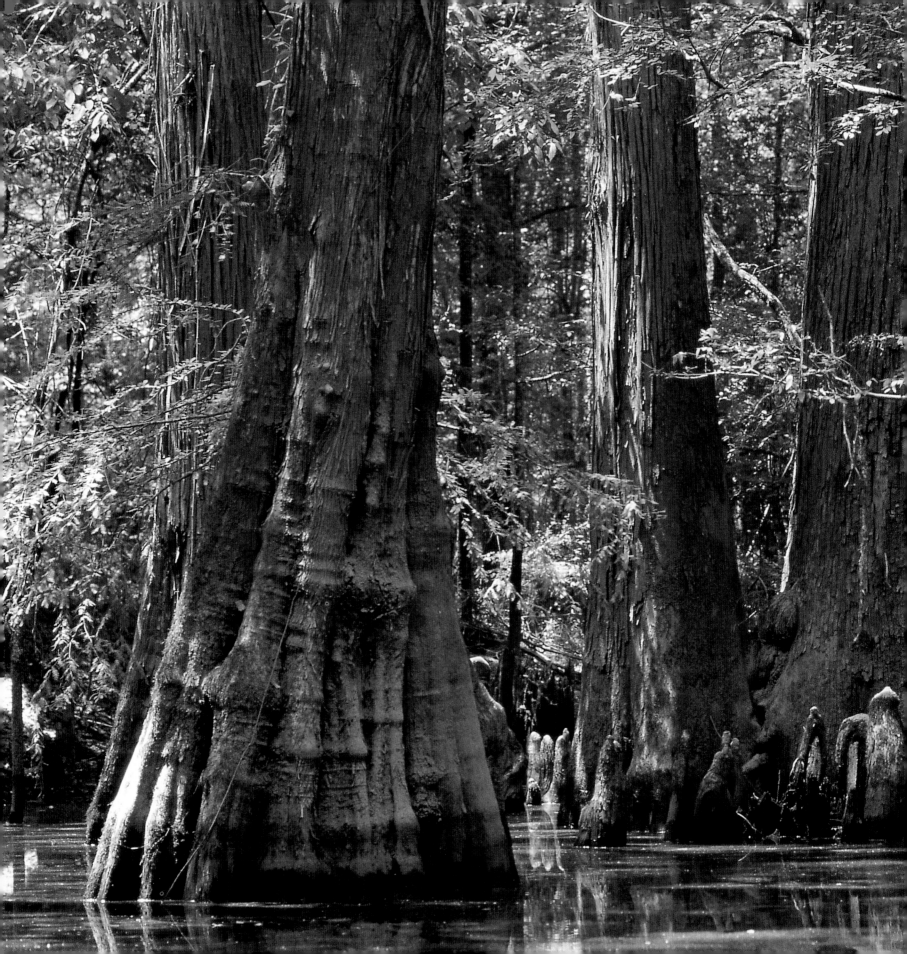

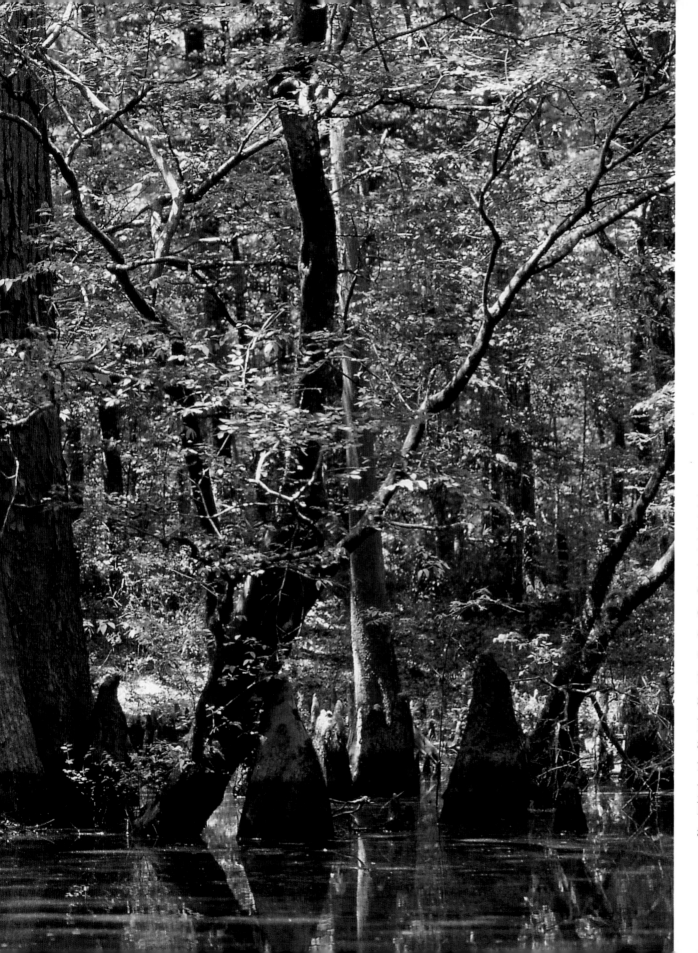

Established in 1974, Big Thicket National Preserve protects portions of a wilderness that once encompassed most of eastern Texas. Combining five distinct ecosystems—swamps, forests, plains, deserts, and Appalachian mountains—the park is home to hundreds of plant and animal species.

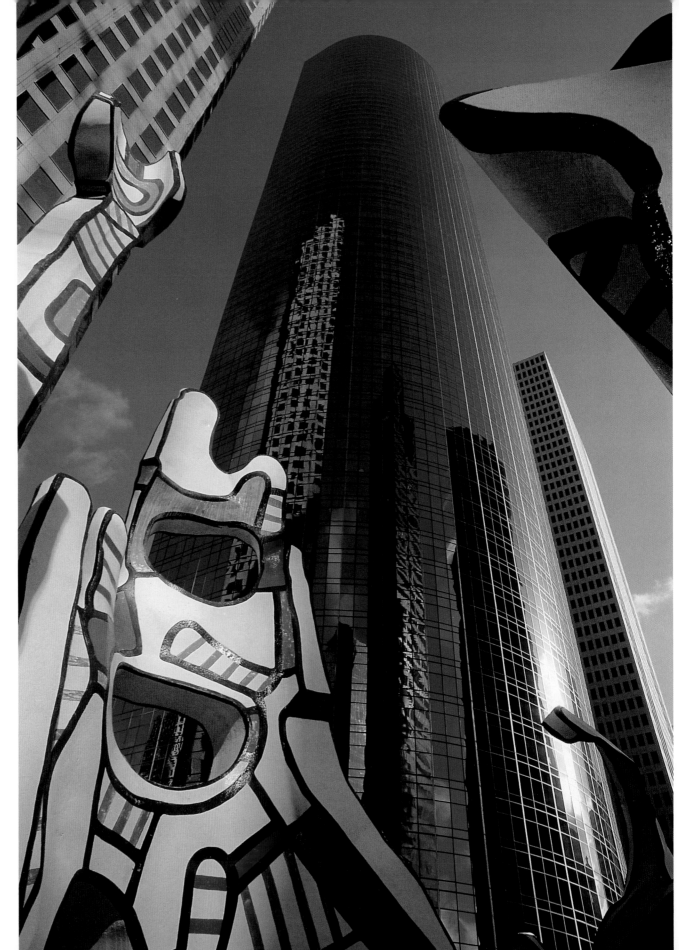

Billed as the city where 11 railroads meet the sea, Houston has been a major commercial center since the 1840s and '50s. More than 400 vessels each year travel Ship Channel, carrying goods to countries around the world.

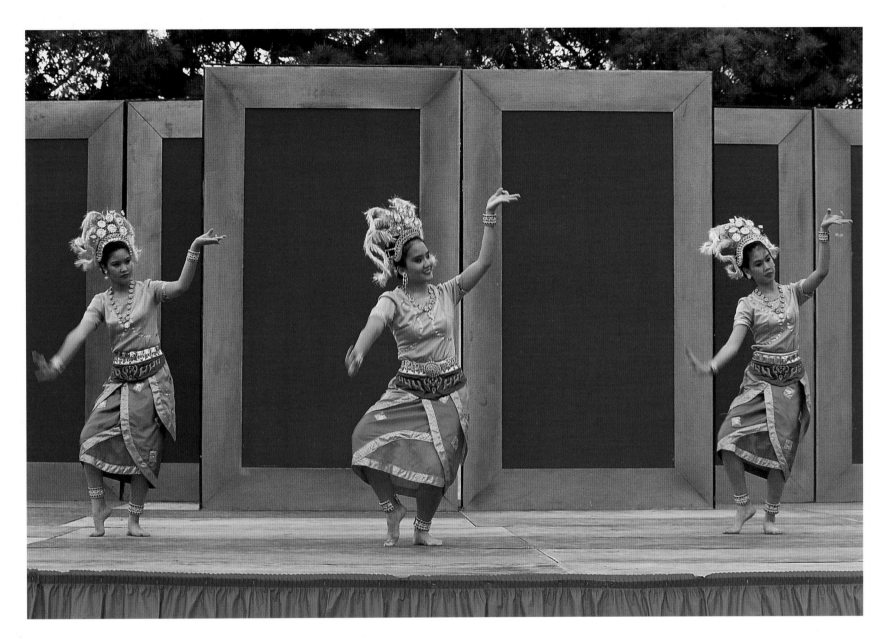

For 10 days each April, the Houston International
Festival highlights the city's diversity with food, crafts,
and performances from around the world.

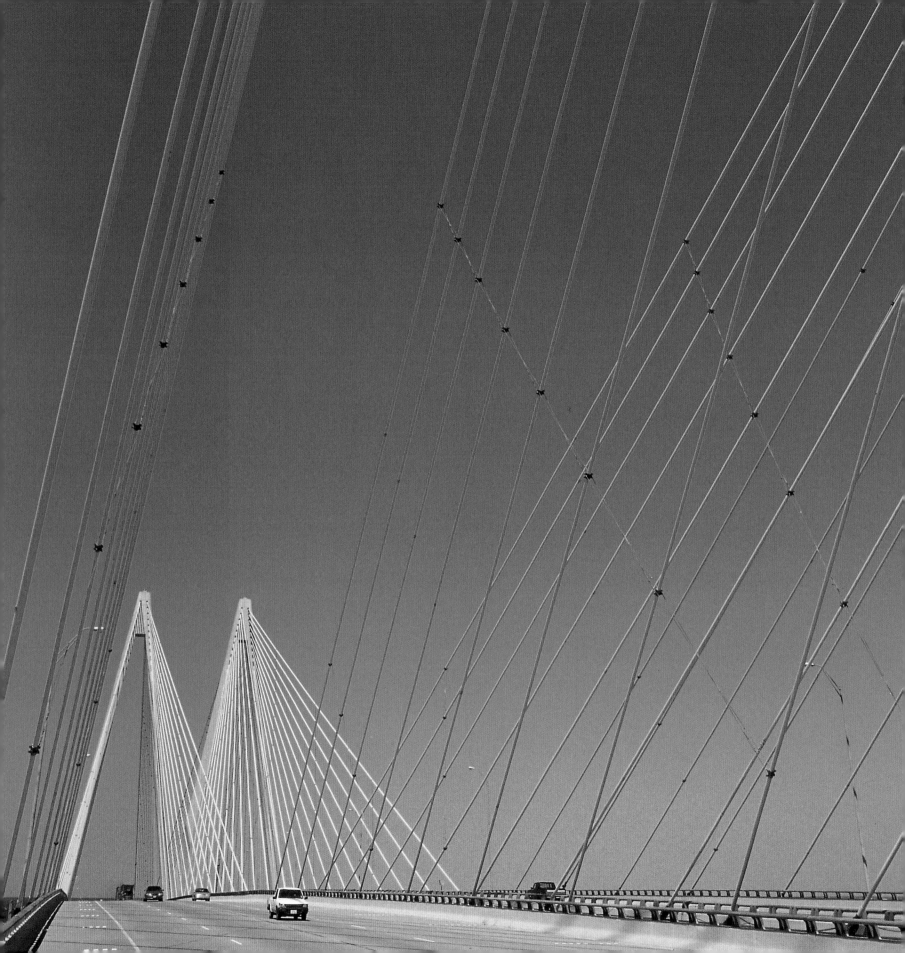

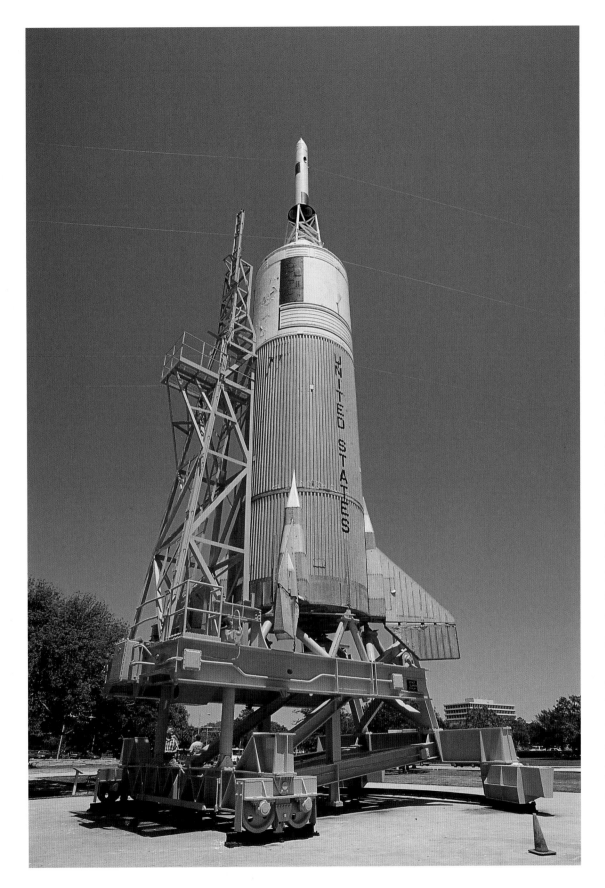

The first word spoken on the moon was "Houston," as the astronauts reported to the Lyndon B. Johnson Space Center. As well as learning intriguing space-related facts, visitors to the center are briefed on NASA's activities of the day, tour astronaut training facilities, and experience the excitement of mission control.

OPPOSITE— Ten waterways winding through the city have earned Houston the title of "Bayou City."

Home to more alligators than people, Anahuac was declared the Alligator Capital of Texas by the legislature in 1989. The Anahuac National Wildlife Refuge is also home to many species of birds. About 250 species have been spotted, and more than 40 nest here.

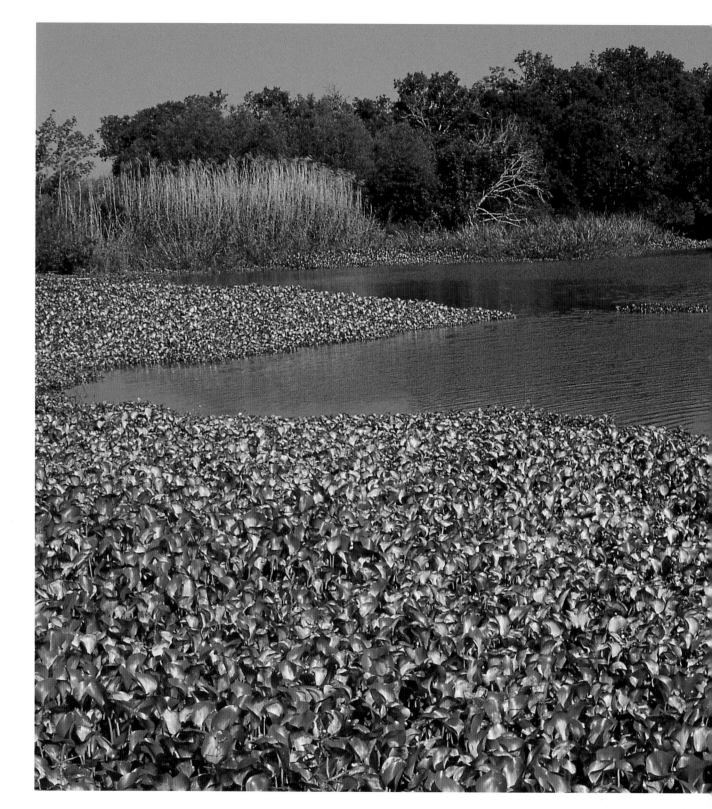

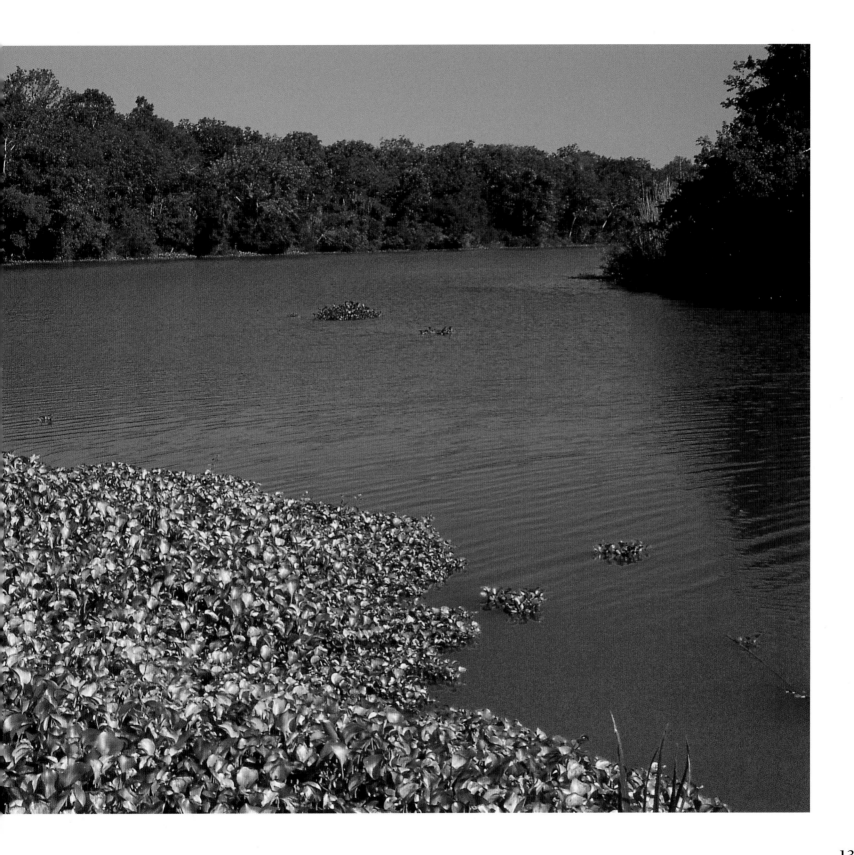

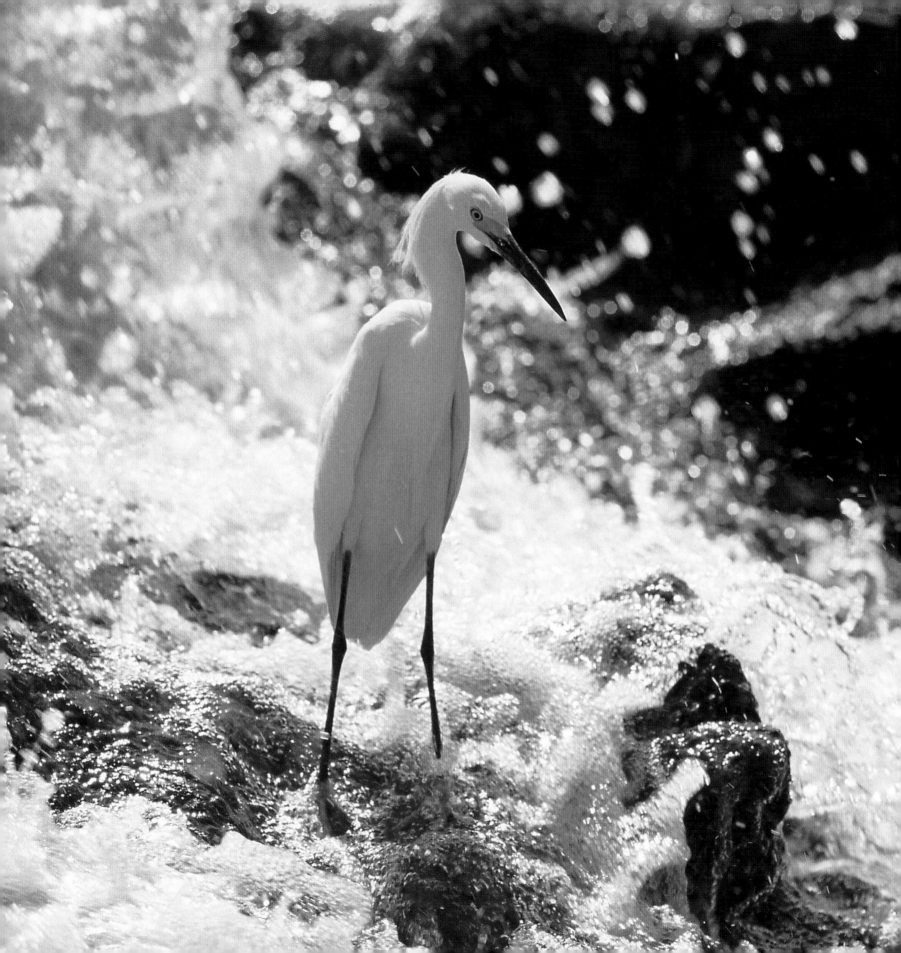

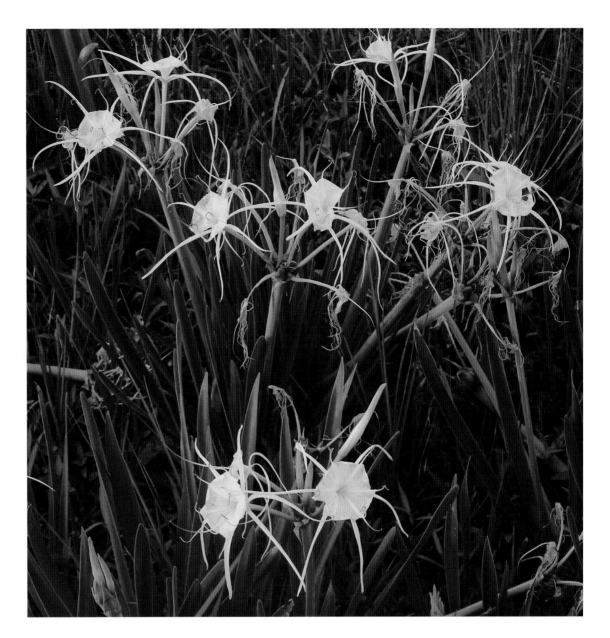

Fragrant spider lilies bloom along a marshy streambed.
These unique flowers thrive only with plentiful moisture,
and are usually seen near ponds or ditches.

Snowy egrets were hunted nearly to extinction in
the late 19th century because of the popularity
of their feathers on hats. Wildlife refuges along
the coast now help to protect the bird.

The log cabin of John P. Coles, who founded the community of Independence (originally called Coles Settlement) in 1824, stands in Old Baylor Park. The town was renamed in 1836 when Texas gained autonomy from Mexico.

OPPOSITE—
Carriages are a common sight along the Strand, one of Galveston's neighborhoods that has been restored to its Victorian-era glory. The original city was destroyed and thousands of residents killed by a hurricane in 1900.

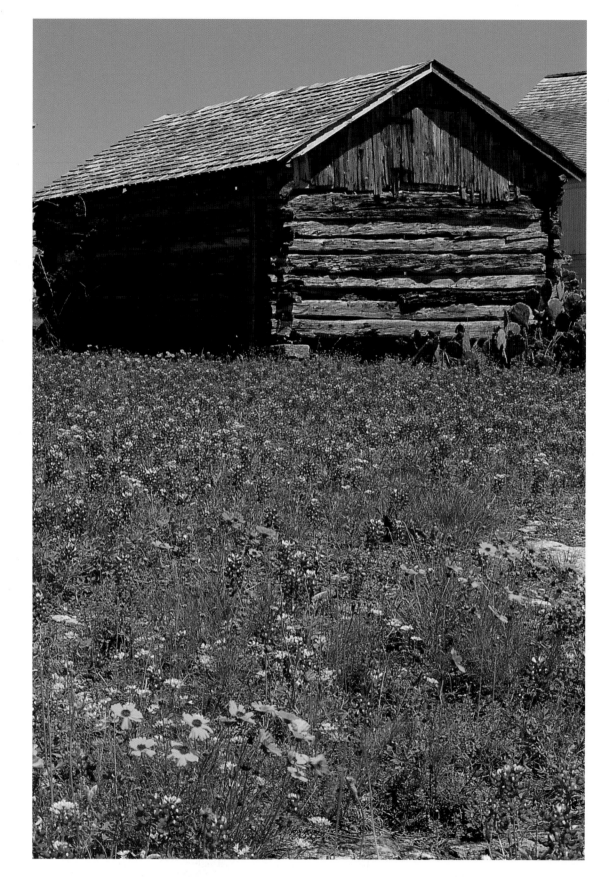

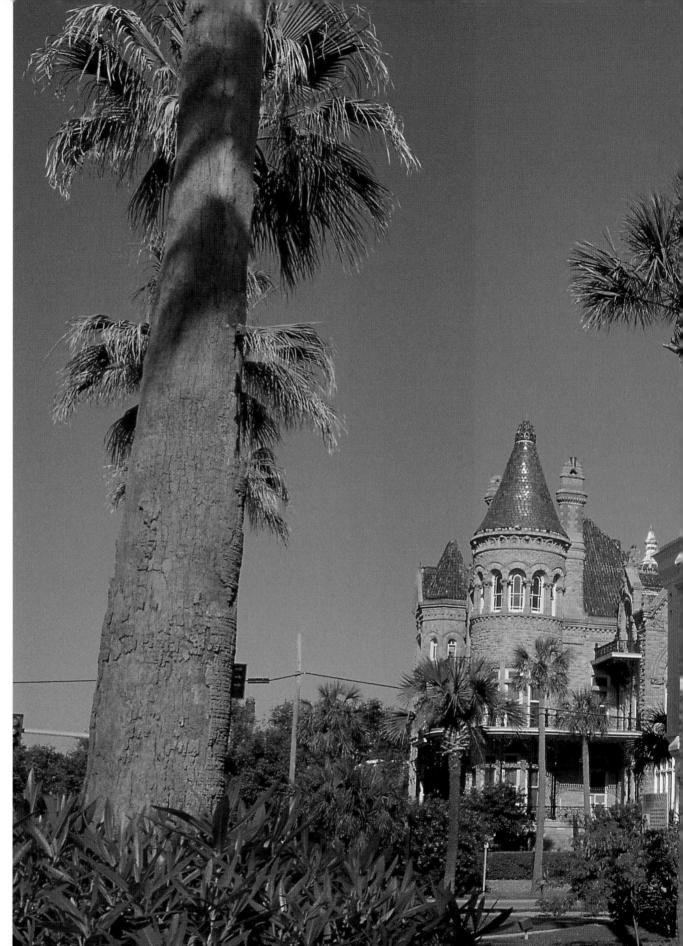

There are more than 1,500 restored historic homes and buildings in Galveston. The Bishop's Palace, in the background of this photo, was built in 1888 for lawyer Walter Gresham and became the home of Bishop Christopher Byrne in 1923. The Sacred Heart Church stands in the foreground.

18

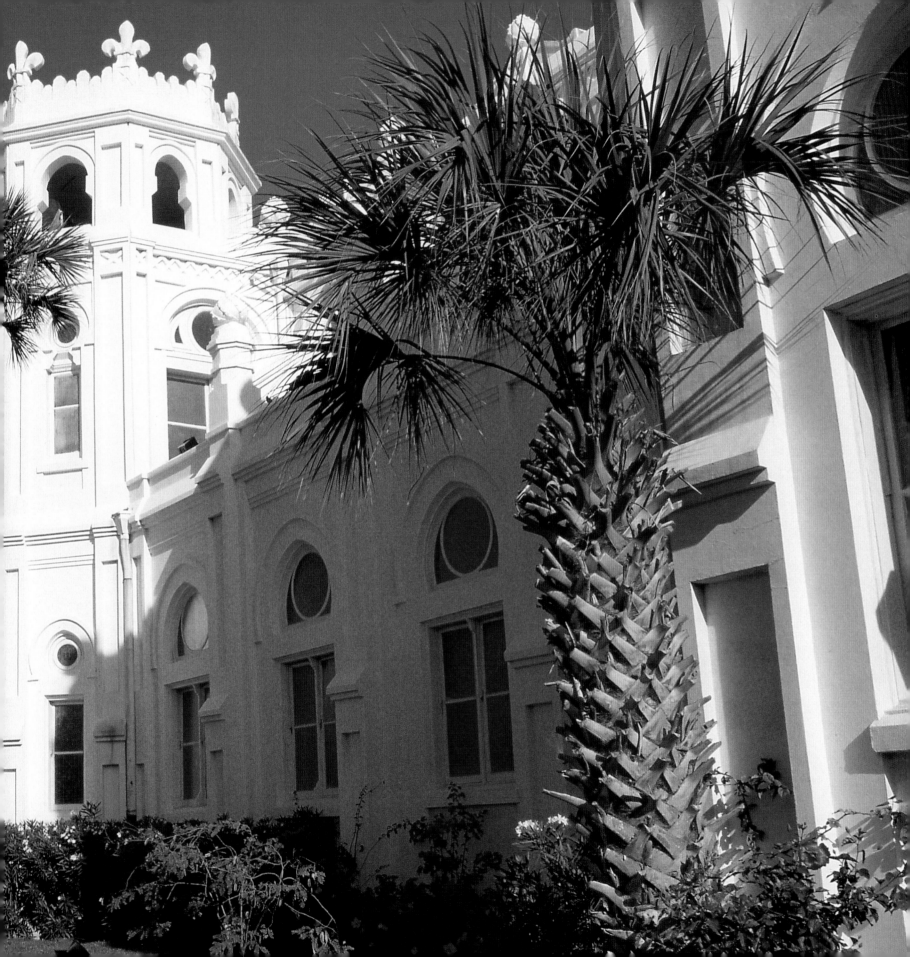

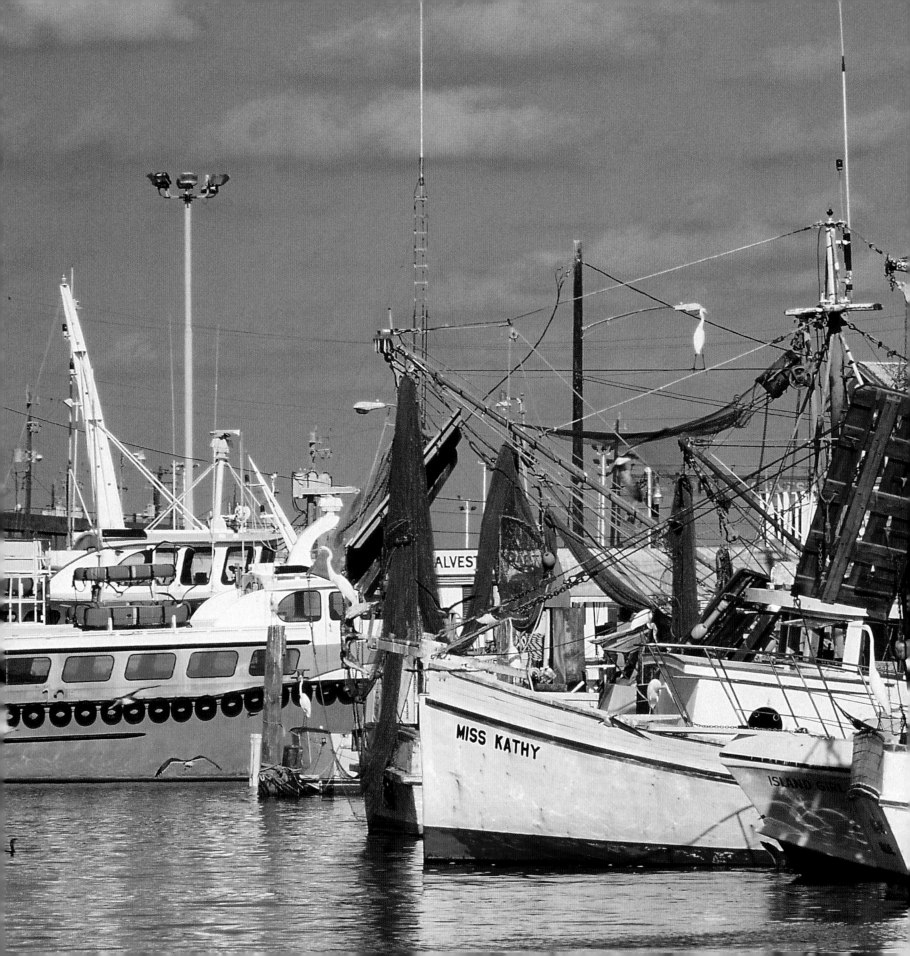

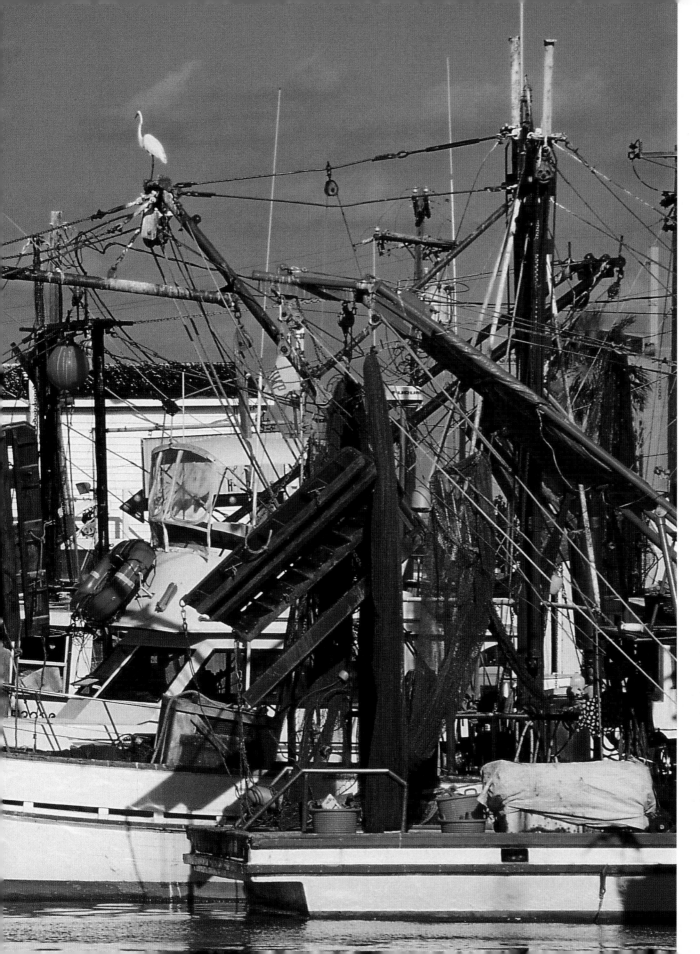

In the early 1800s, Galveston—then called Campeachy—was a pirate base, from which Jean Lafitte and his followers attacked and plundered Spanish ships. The city remains a major port, but now hosts more reputable business.

21

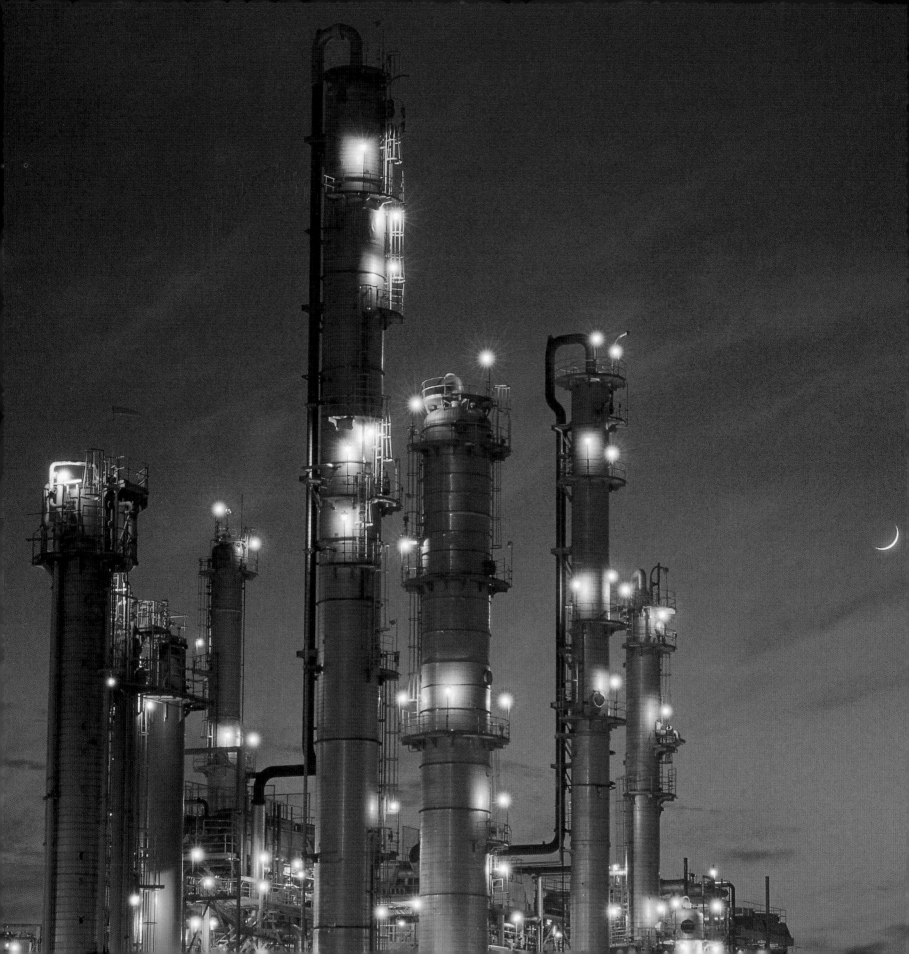

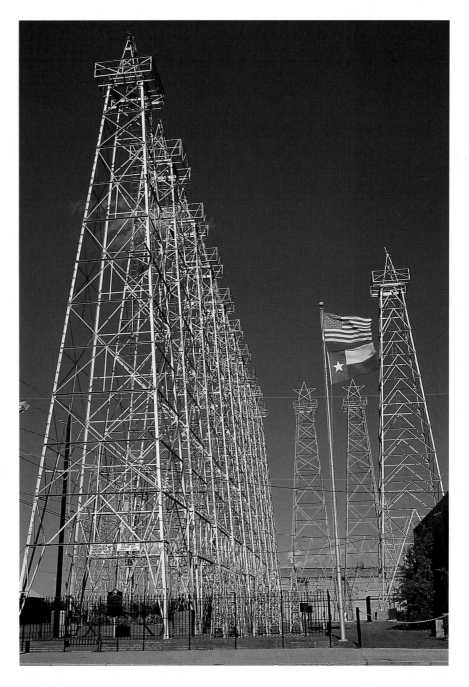

The 13 oil derricks on the World's Richest Acre commemorate the 1930s, when 24 wells shared this small plot of land, producing more than 2.5 million barrels of oil.

The lights of an oil refinery glow in the night near Texas City. The town is also home to several other industries, including a tin smelter and chemical plants.

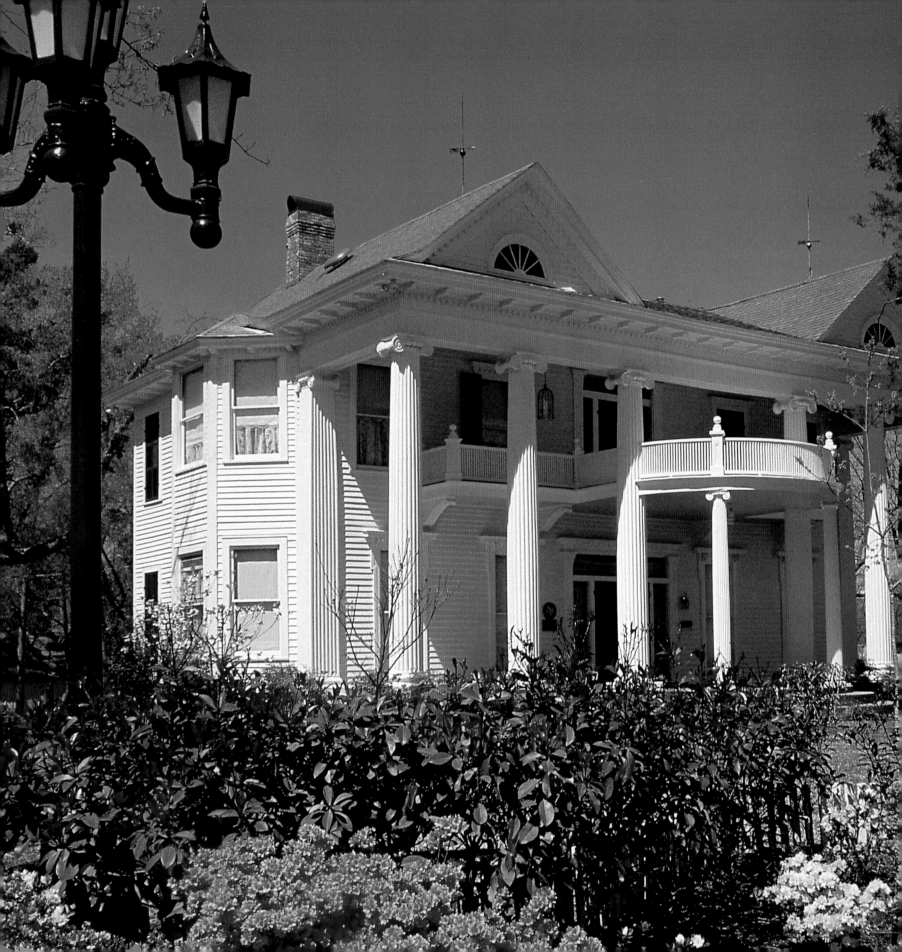

Victorian homes throughout Palestine make walking tours of the town a favorite pastime for visitors. This elegant 19th-century home, which belonged to Henry and Hypatia Link, remains a private residence.

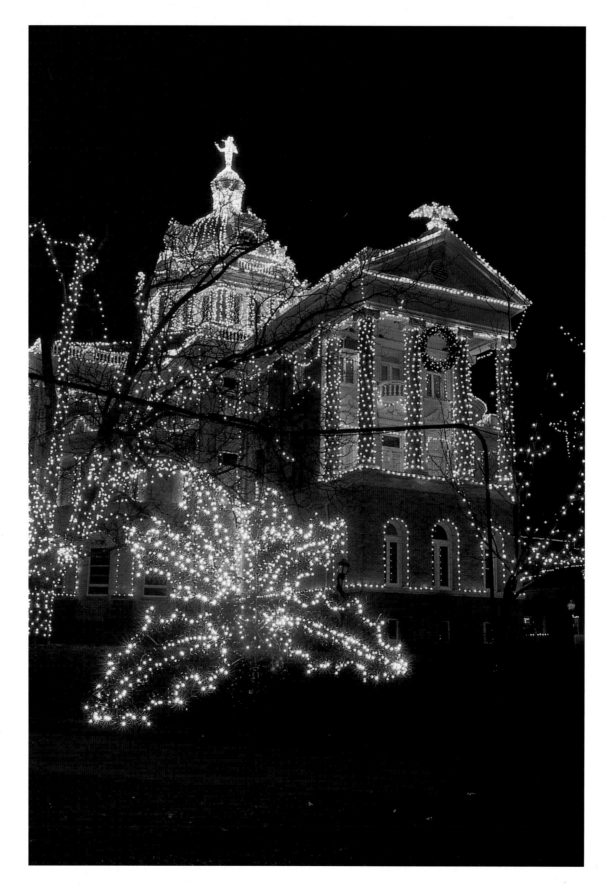

This former Harrison County Courthouse in Marshall has been restored and is now home to the county museum. In the mid-1800s, Marshall was one of the largest commercial centers in Texas.

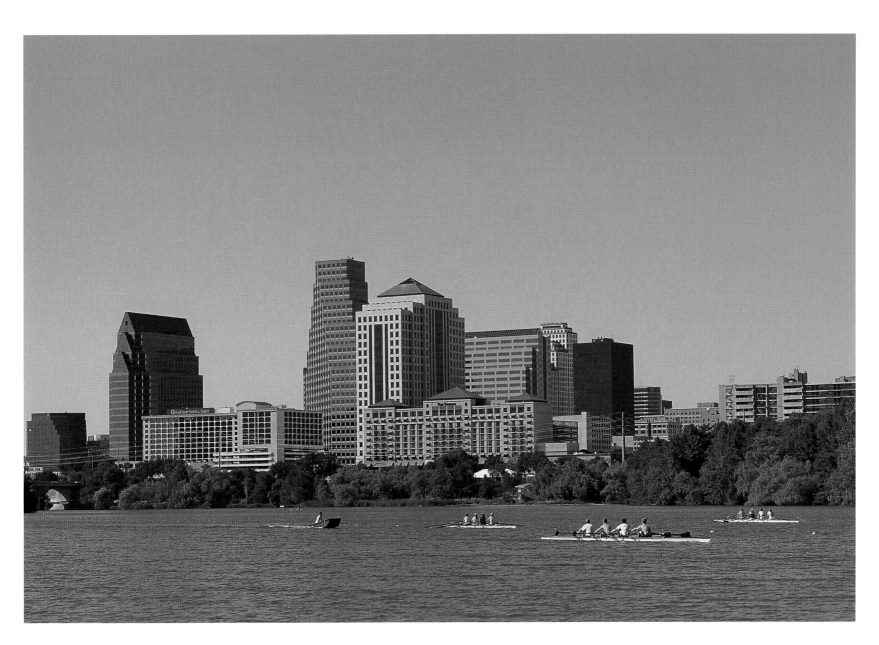

Stephen F. Austin founded the first American settlement in Texas—and the state's capital was renamed in his honor. Before it was chosen to become the capital in 1839, the community was known as Waterloo.

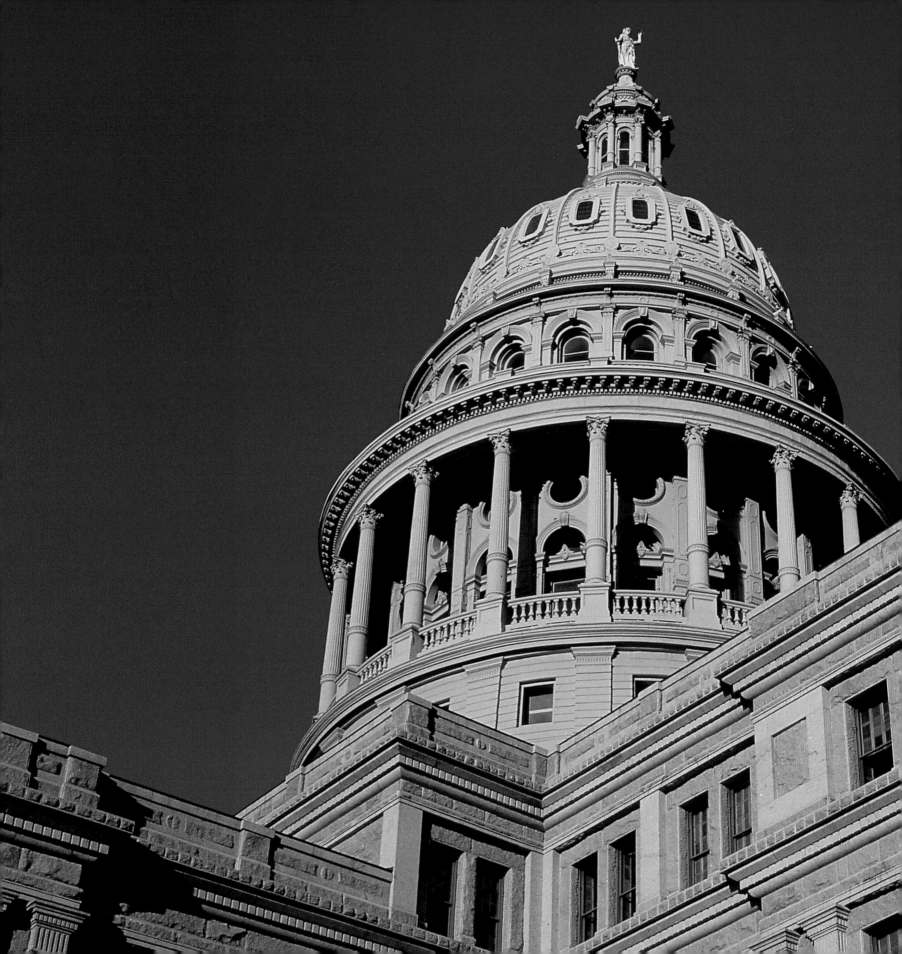

The nation's largest domed state capitol building, the Texas Capitol was built in the late 1800s. Pink granite native to the state was used for the walls—about 15,000 railway cars of stone.

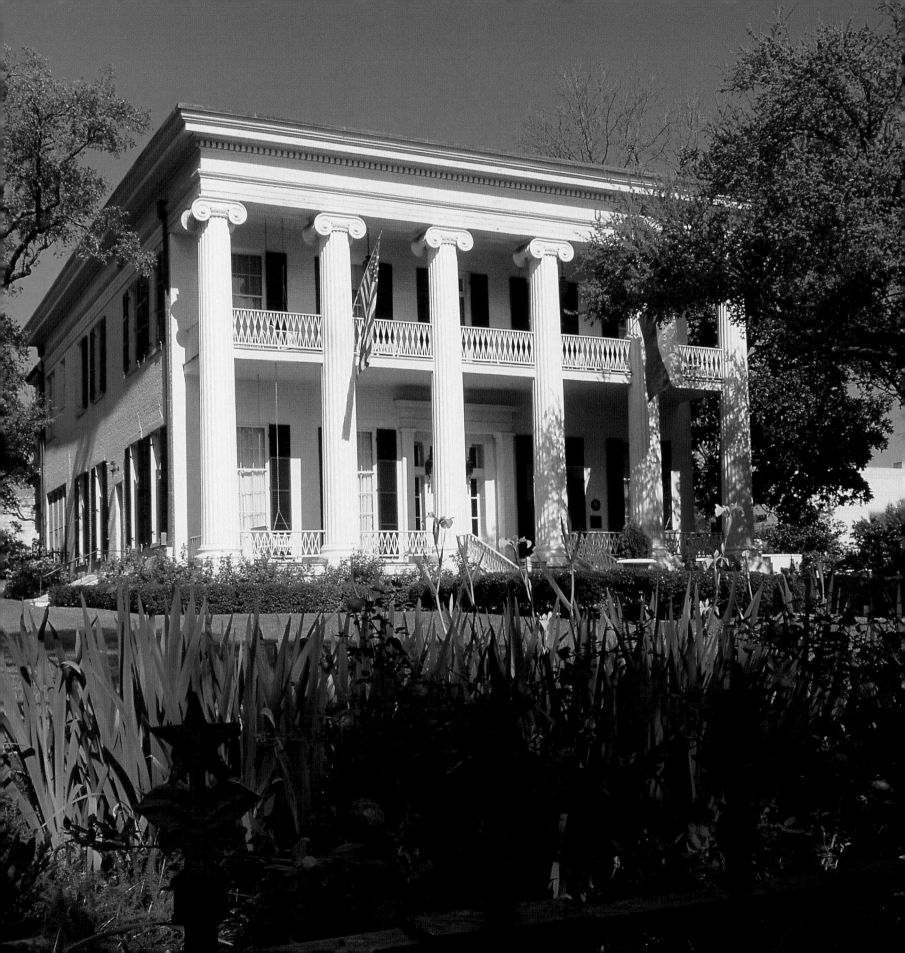

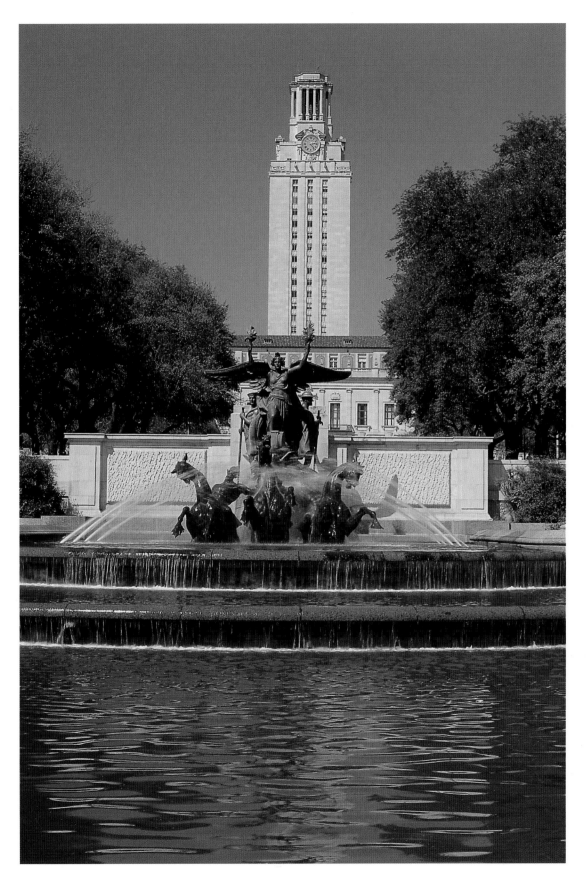

When the University of Texas opened its doors in 1883, 8 instructors led classes for 221 students. Since then, this major research university has awarded over 385,000 degrees.

OPPOSITE—
The state's governors have resided in this Austin mansion since 1856, when Governor Elisha Pease moved in. Parts of the building, furnished in 19th-century antiques, are now open to the public.

The oldest university in Texas, Baylor University was chartered in 1845. Students from 50 states and 70 countries attend 156 undergraduate and more than 80 graduate programs.

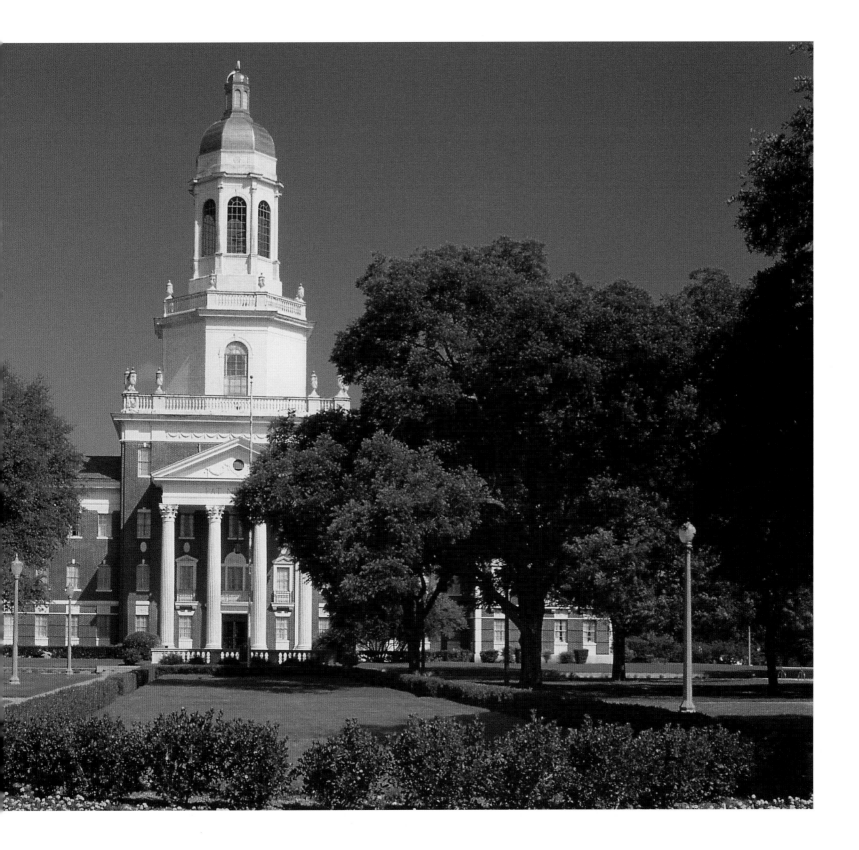

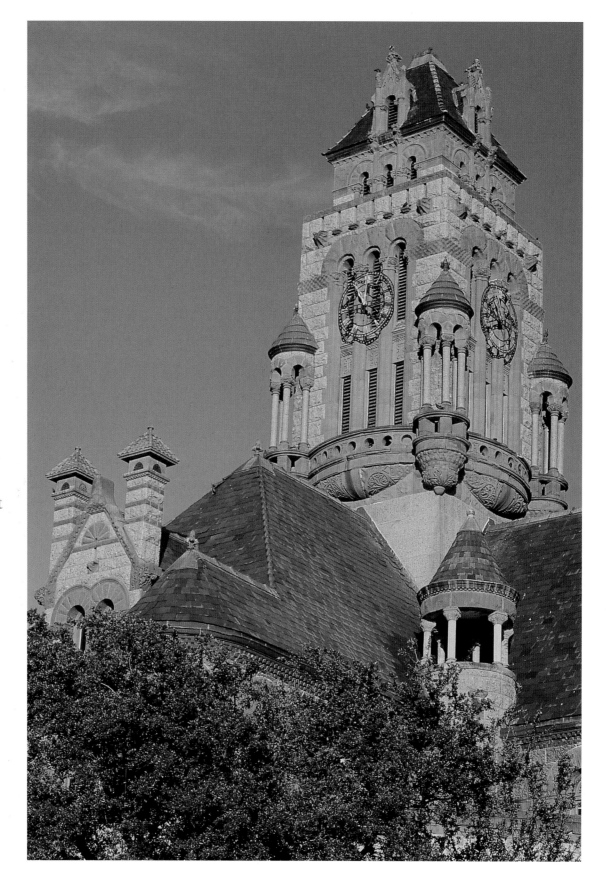

Artisans were brought to Waxahachie from Italy to carve the stone for the Ellis County Courthouse, built in 1895. The courthouse is one of many historic buildings in the city. In fact, one-fifth of the Texas sites listed on the National Register of Historic Places are in Waxahachie.

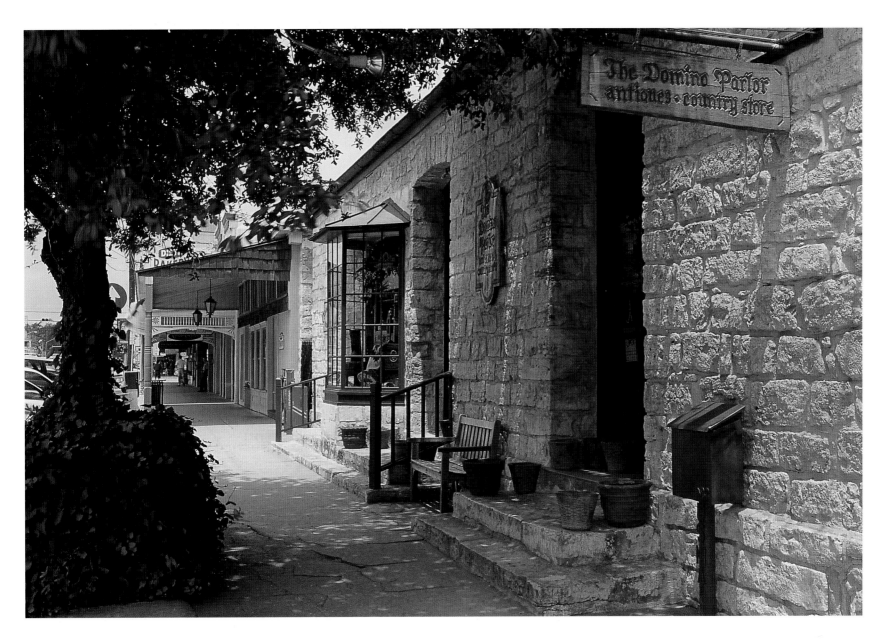

Fredericksburg was settled by German immigrants in the mid-19th century, and visitors may still hear German spoken in the streets. Many of the buildings in downtown Fredericksburg are more than a century old and are part of a National Historic District.

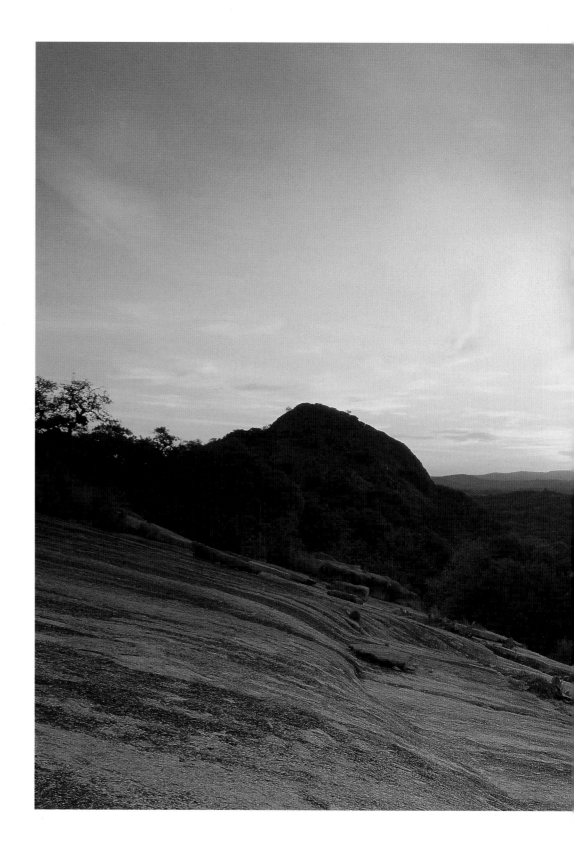

About 500 feet high, the unique formation at Enchanted Rock State Park features prominently in many Native legends. In some stories, it is a place of human sacrifice; in others, it's a place of worship.

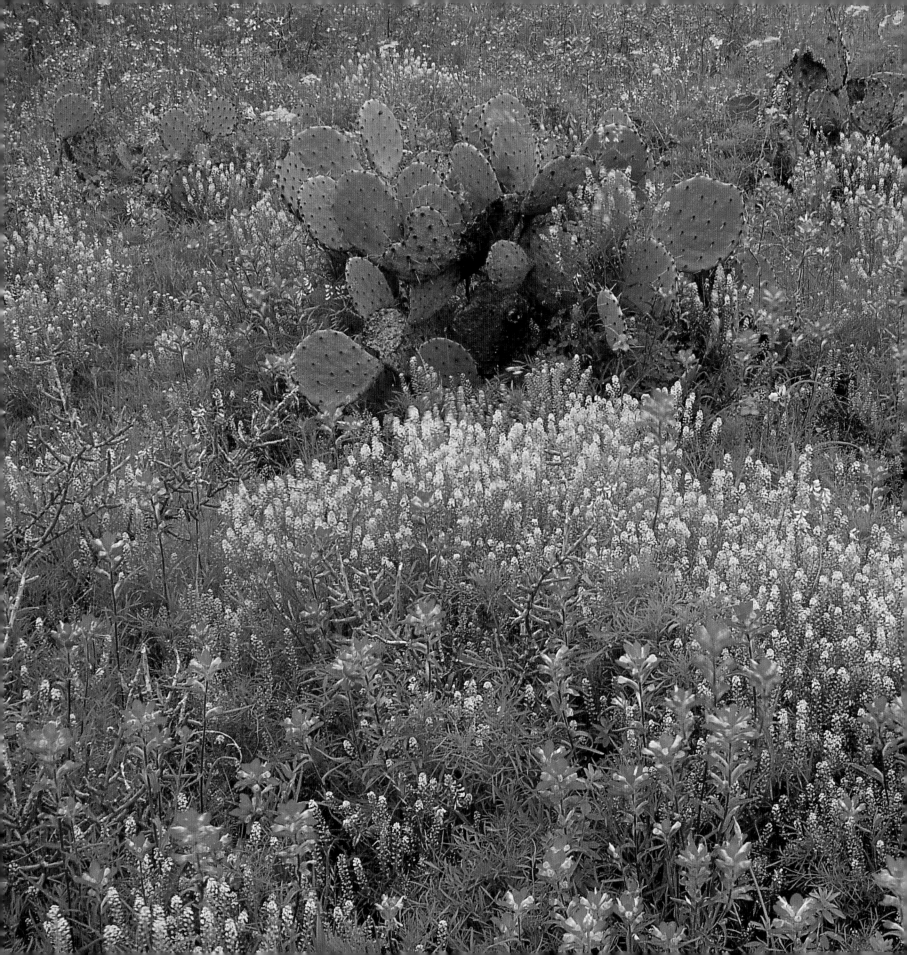

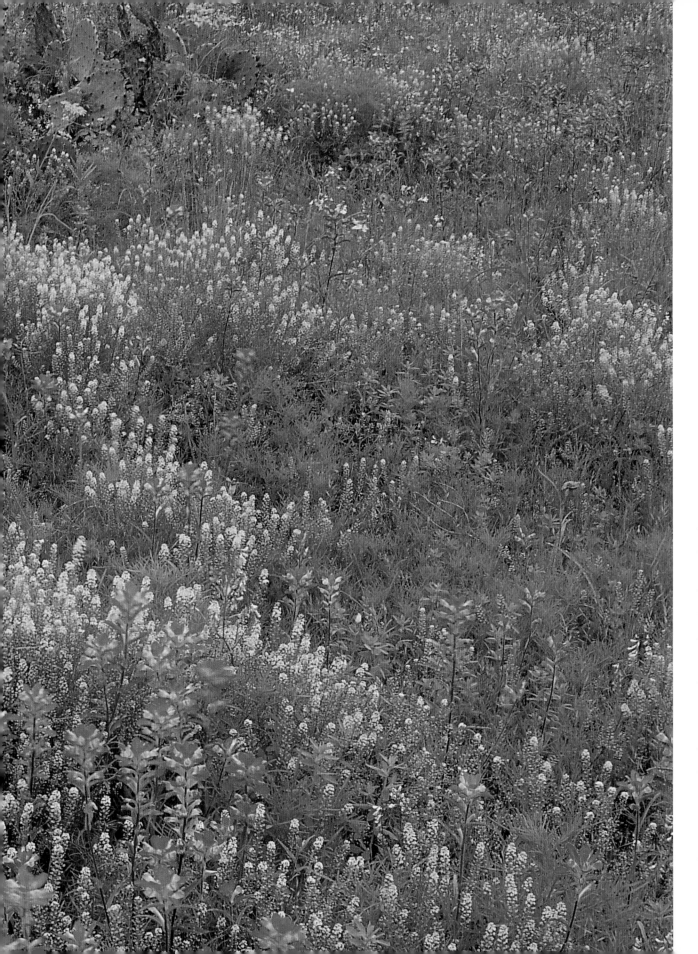

Indian paintbrush, peppergrass, and prickly pear cactus decorate the scenic hill country near Llano. Along with wildflowers, this area is known for its rock-hunting opportunities. Part of a geographical uplift, Llano county is a wonderful place to find amethyst, dolomite, garnet, quartz, and other interesting stones.

39

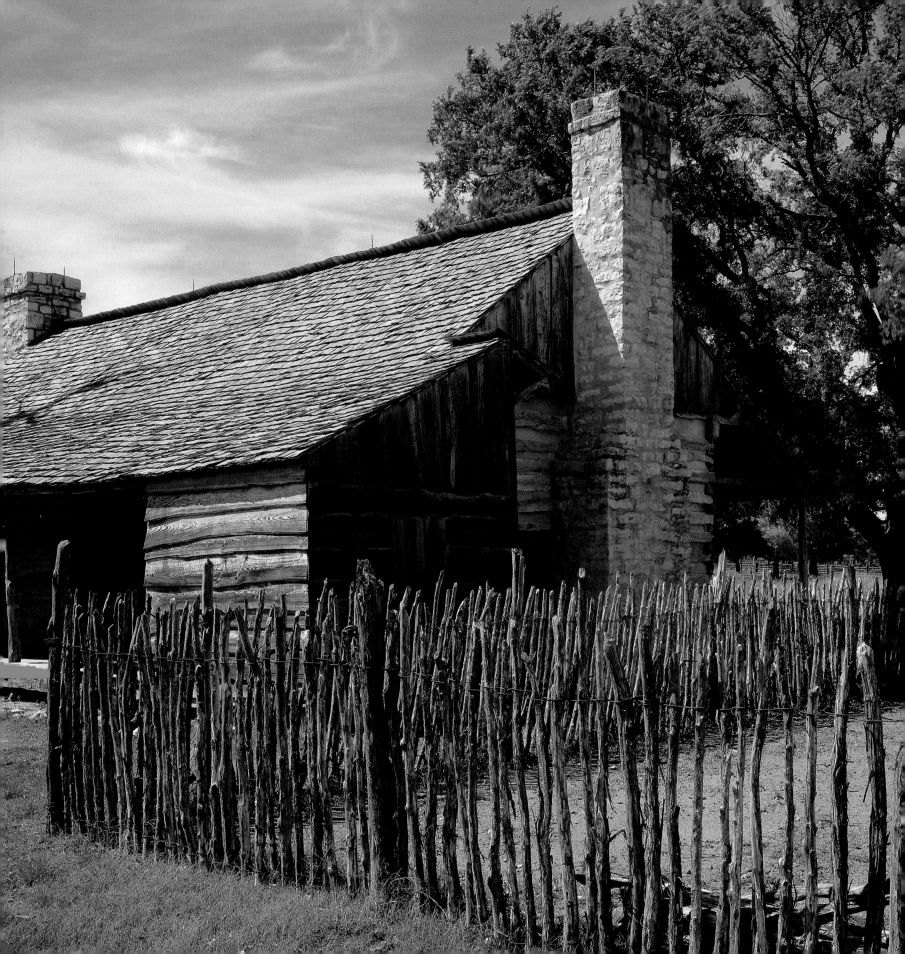

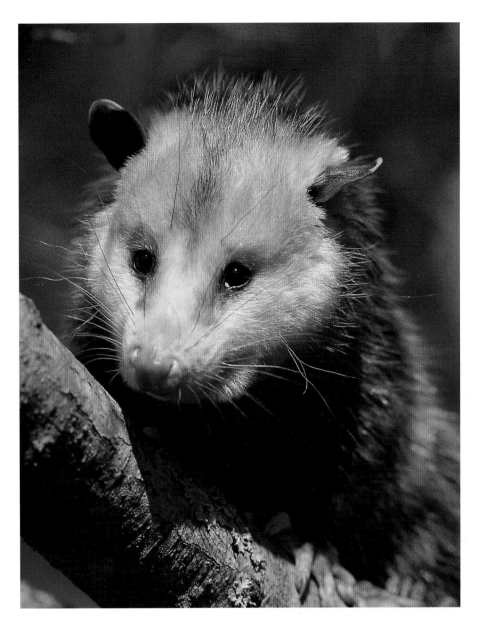

North America's only marsupial, an opossum may carry a dozen young in her pouch. This adaptable creature was once a denizen of South America, but has steadily expanded its range northward since the last ice age.

Lyndon B. Johnson National Historic Park preserves the farmstead where the president's parents moved in 1914, the school the president attended, and the ranch and home of his grandfather. The ranch remains in operation today.

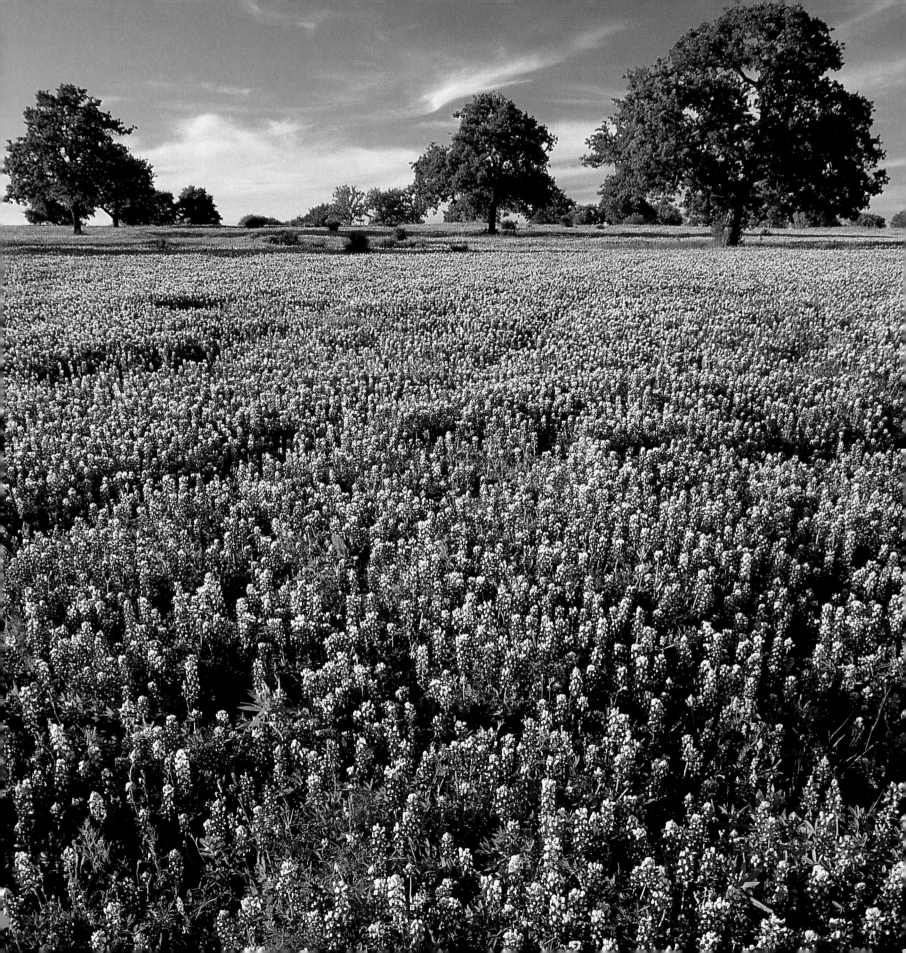

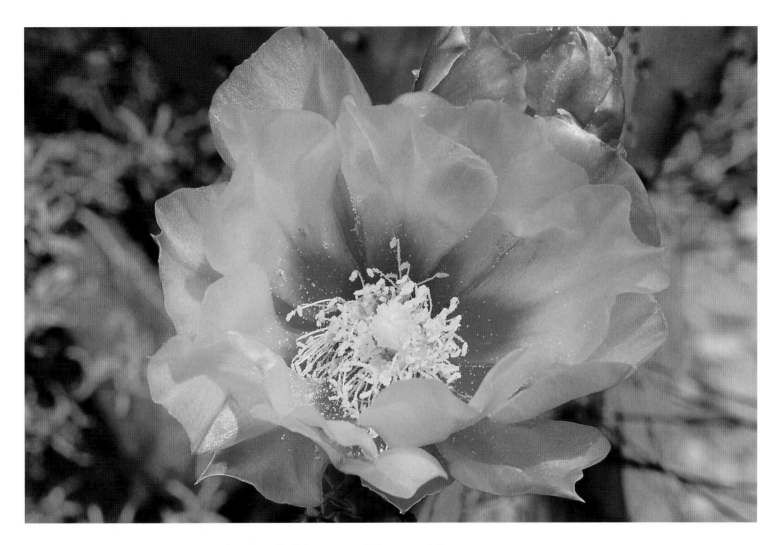

The dramatic yellow to dark purple blooms of the prickly pear cactus seem deceptively delicate. This is actually one of the hardiest cactuses.

Just one of more than 5,000 wildflower species in Texas, bluebonnets bloom prolifically each spring. Bluebonnets are a state flower, along with the other lupine species found in Texas.

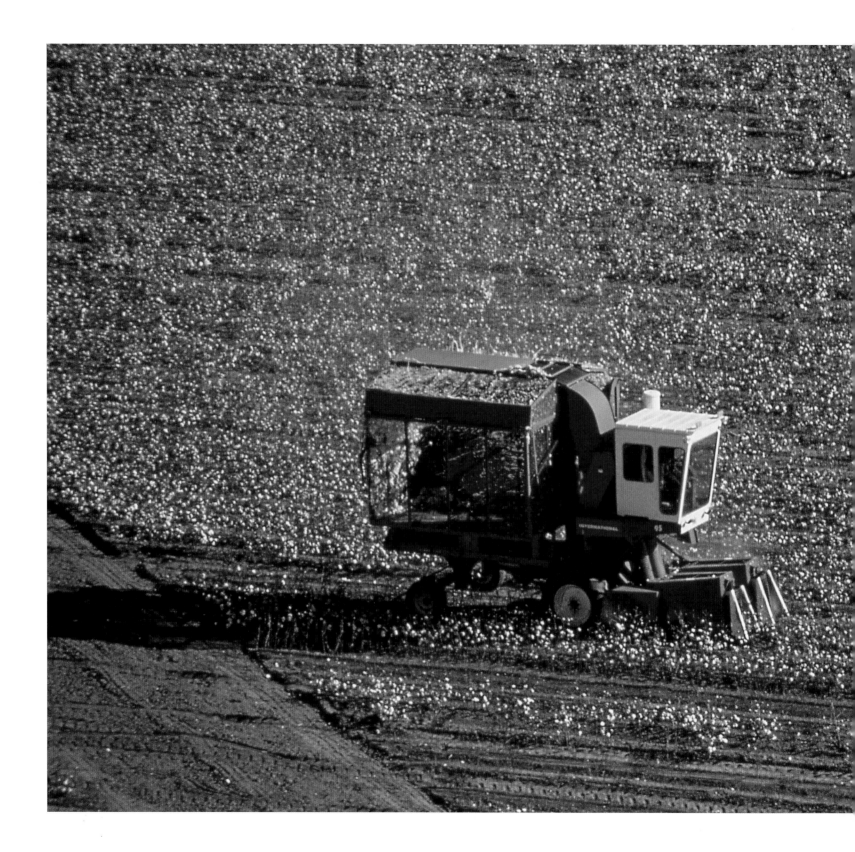

More than 5.5 million acres of cotton are harvested in Texas each year, making the crop a billion-dollar industry.

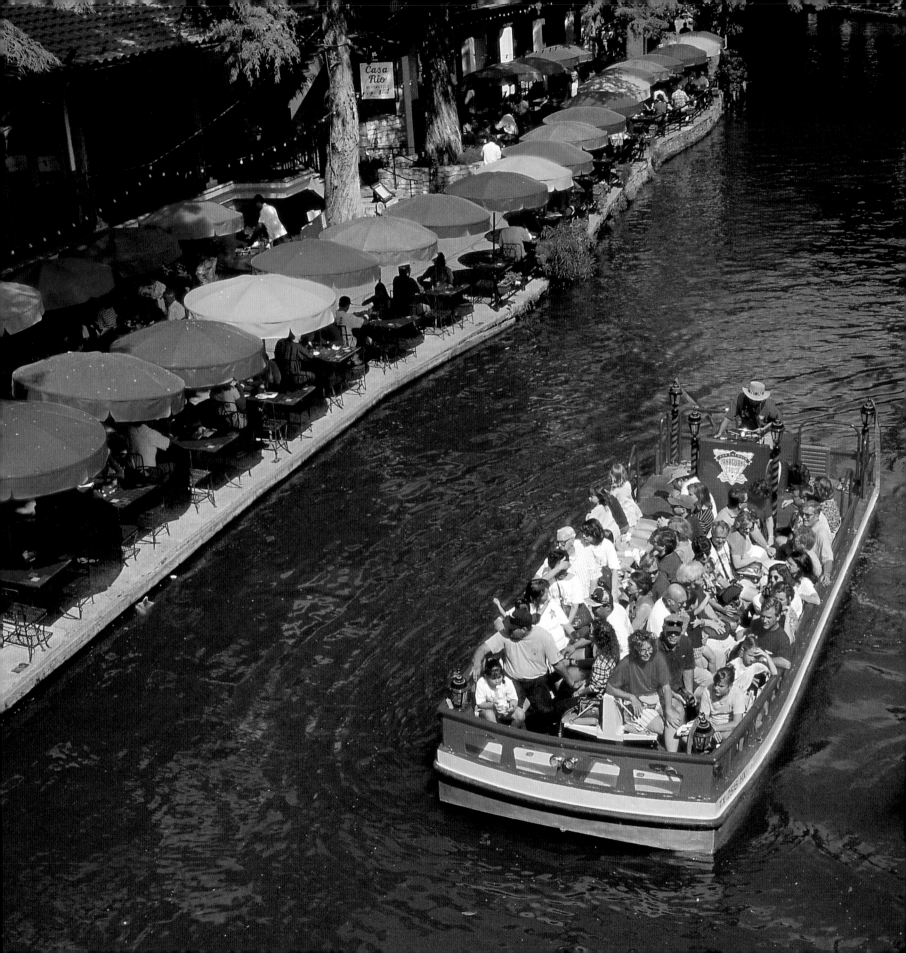

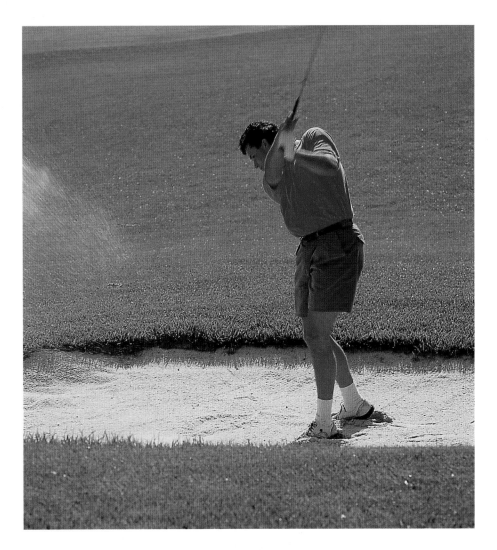

A golfer enjoys an afternoon escape at one of hundreds of Texas courses. The state hosts four PGA events each year.

San Antonio's most popular attraction, the River Walk draws 10 million visitors each year. Some choose to cruise the area on one of the many riverboats, enjoying live music, fine dining, or a fascinating narrated tour of local history.

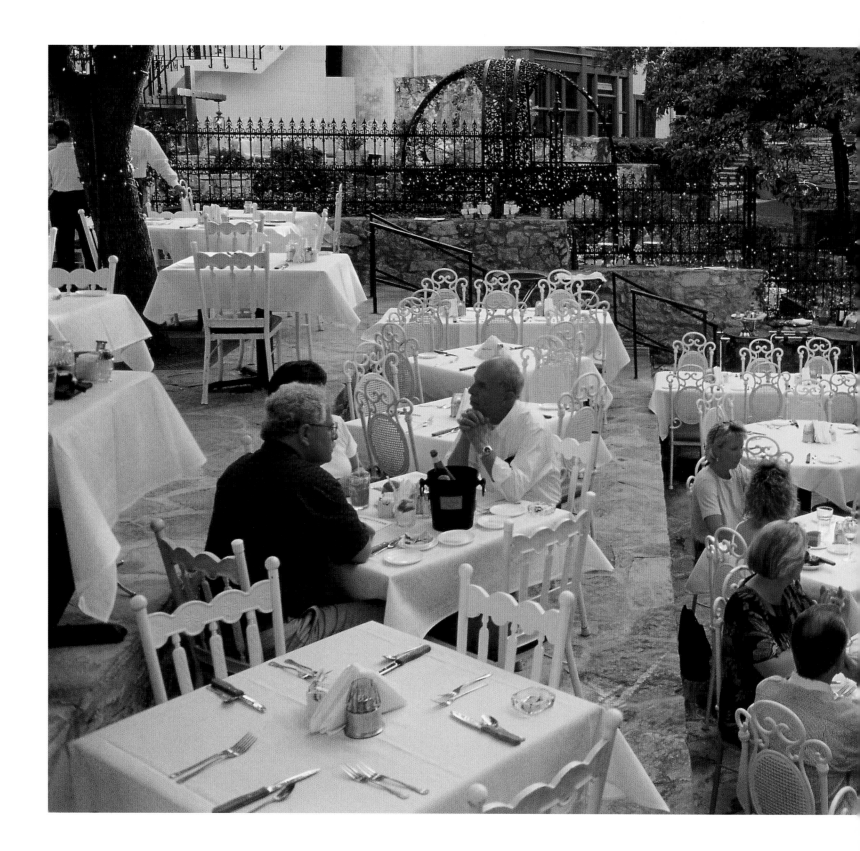

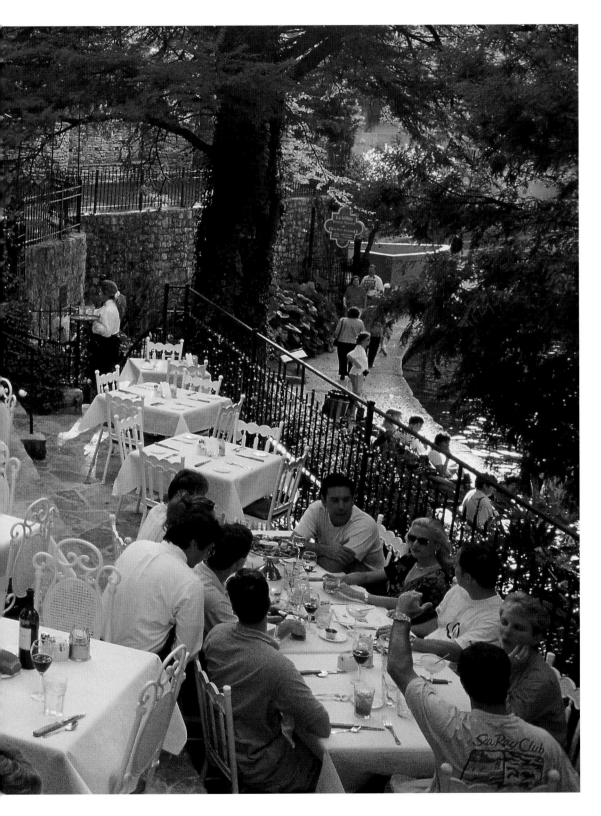

Visitors enjoy a romantic café along the River Walk on the shores of the San Antonio River. Boutiques, galleries, night-clubs, and hotels also line the river.

The Alamo was built as a Spanish mission in the early 18th century. In 1835, fewer than 200 defenders faced 10 times that number of Mexican attackers, led by Mexican General Antonio Lopez de Santa Anna. The defenders fought to their deaths, waiting for reinforcements that never arrived.

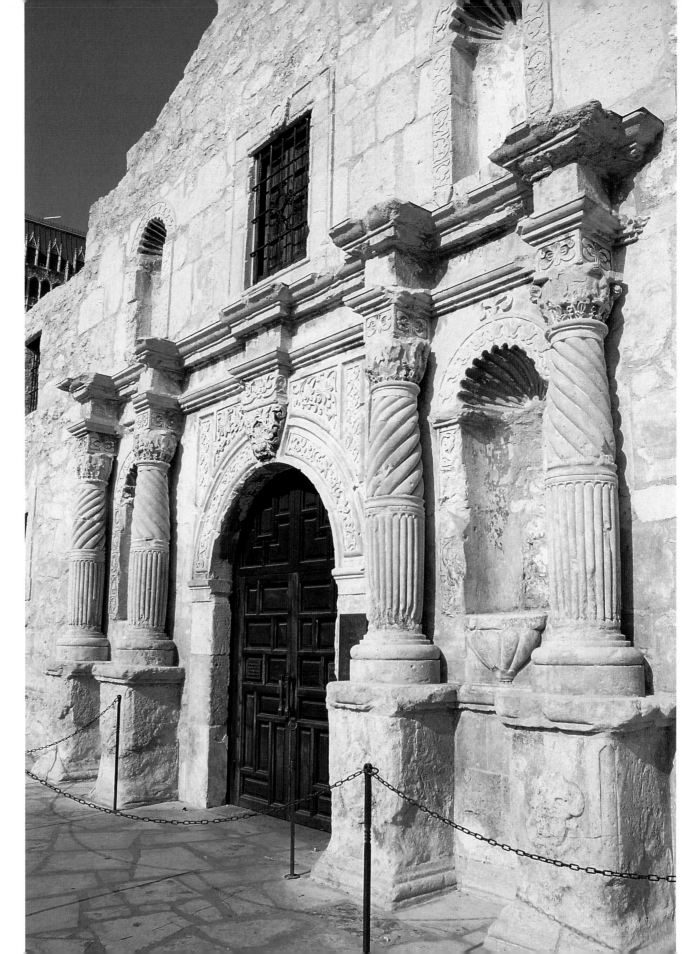

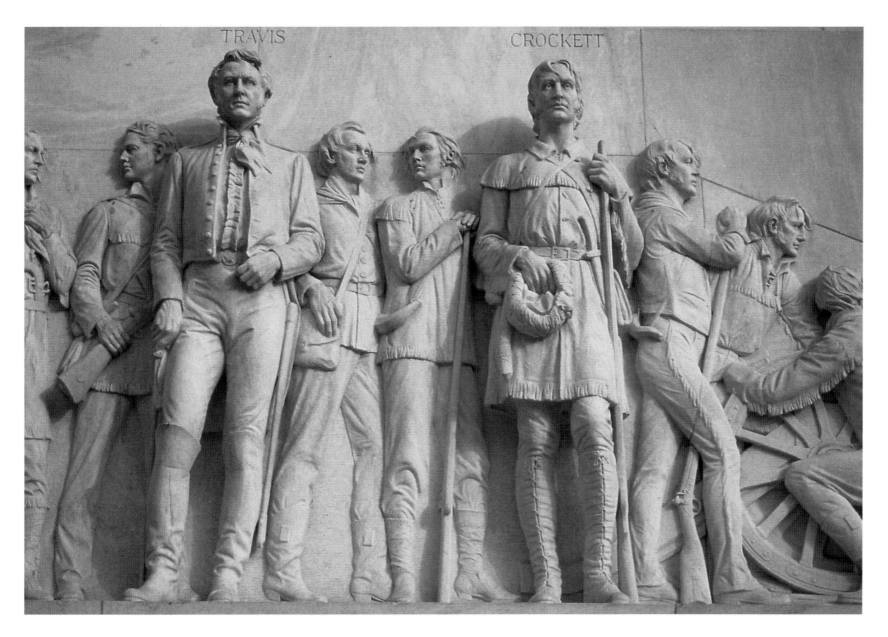

Davy Crockett and Jim Bowie were among the men who fought at
the Alamo—characters now immortalized by Hollywood movies.

America's ninth largest city, San Antonio combines the commerce of a modern urban center with the charm of rich history.

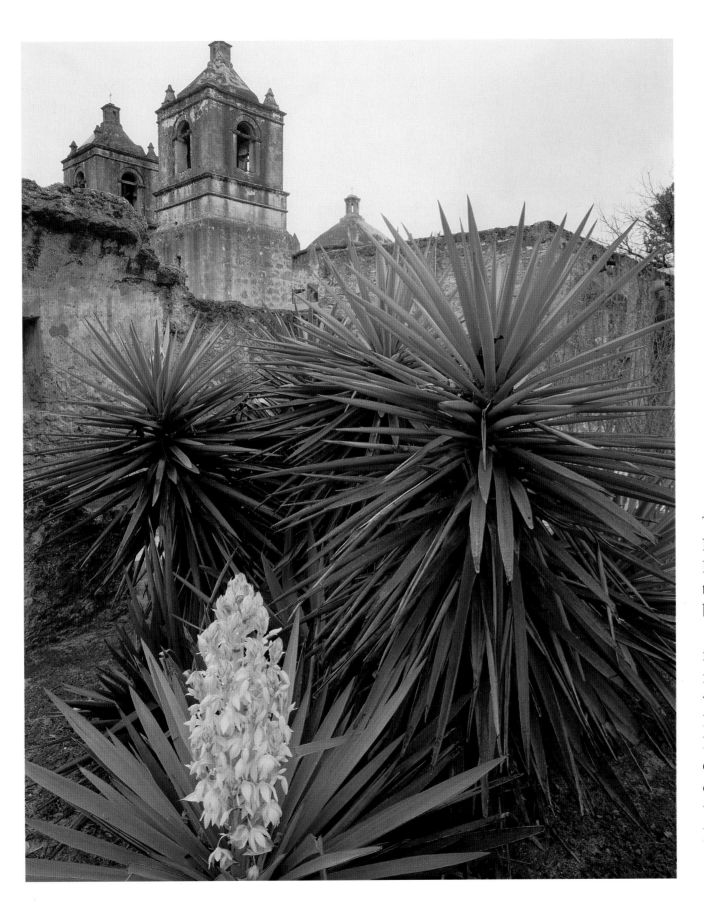

The San Antonio Missions National Historic Park protects four missions built in the early 1700s by Franciscan friars. Though the friars' main intent was to convert the Native residents of New Spain and extend the Spanish control of the colony, they also pledged to protect the people.

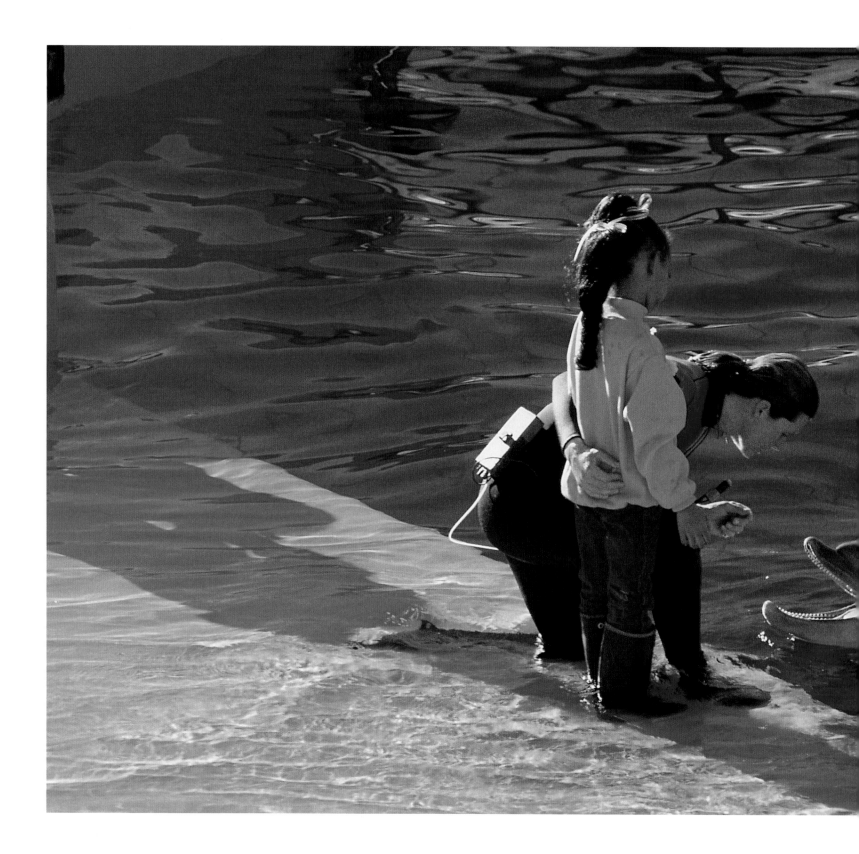

Boasting 250 acres of hair-raising roller-coaster rides, water-slides, wave pools, and exhibits, Sea World is also home to a vast collection of fish and sea mammals. From penguins and dolphins to killer whales and hammerhead sharks, the creatures of Sea World amaze thousands of guests each year.

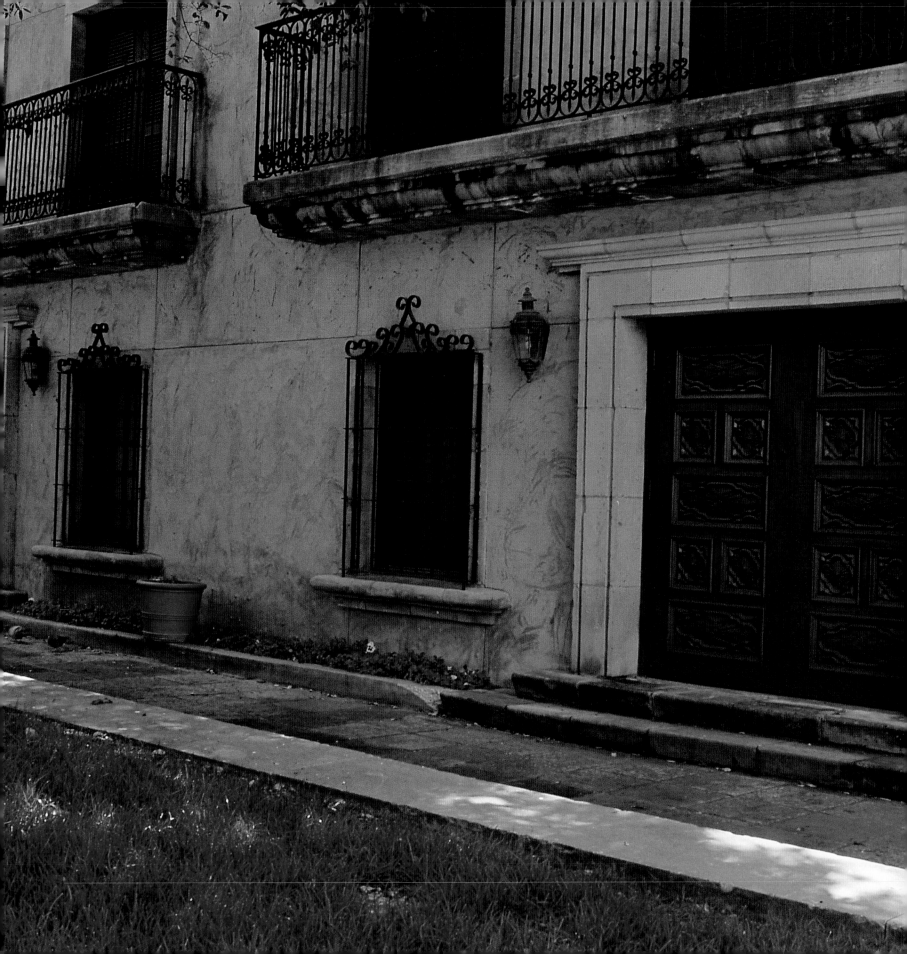

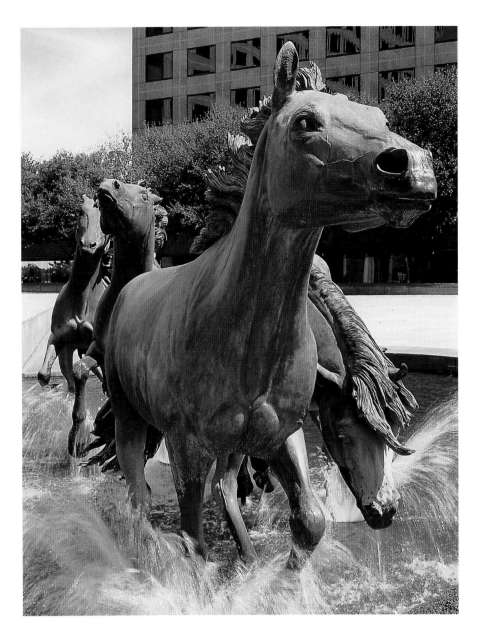

African artist Robert Glen spent seven years creating *Mustangs of Las Colinas,* a bronze sculpture in the center of Irving's Las Colinas recreation and business complex.

Visitors to Irving can explore the shops and cafés along the Mandalay Canal Walk, experiencing a European atmosphere complete with Venetian gondolas.

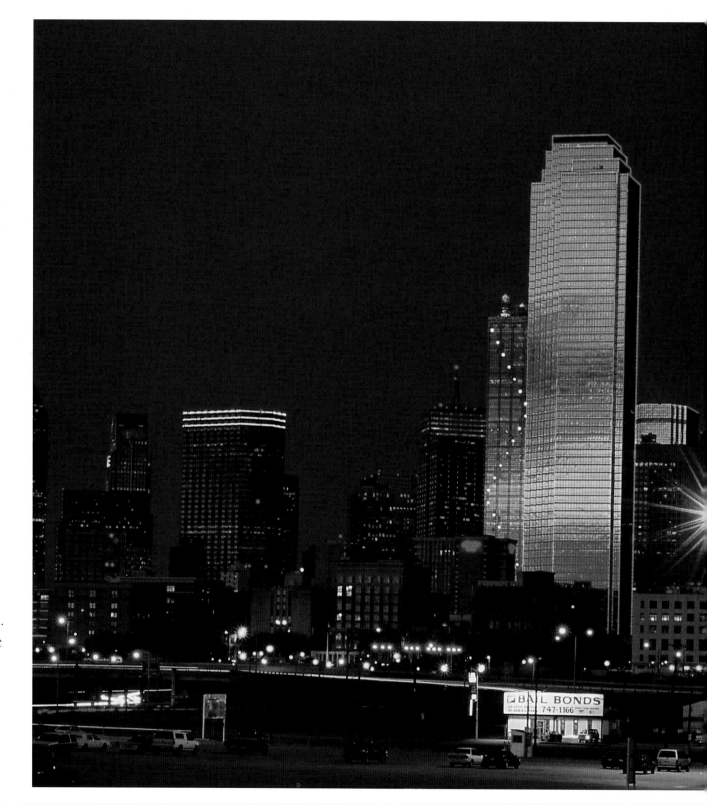

The most striking building on the Dallas skyline is Reunion Tower (far right), adjoining the Hyatt Regency Hotel. Visitors who ride the elevator to the top of the tower can enjoy fine dining and a panoramic view of the city.

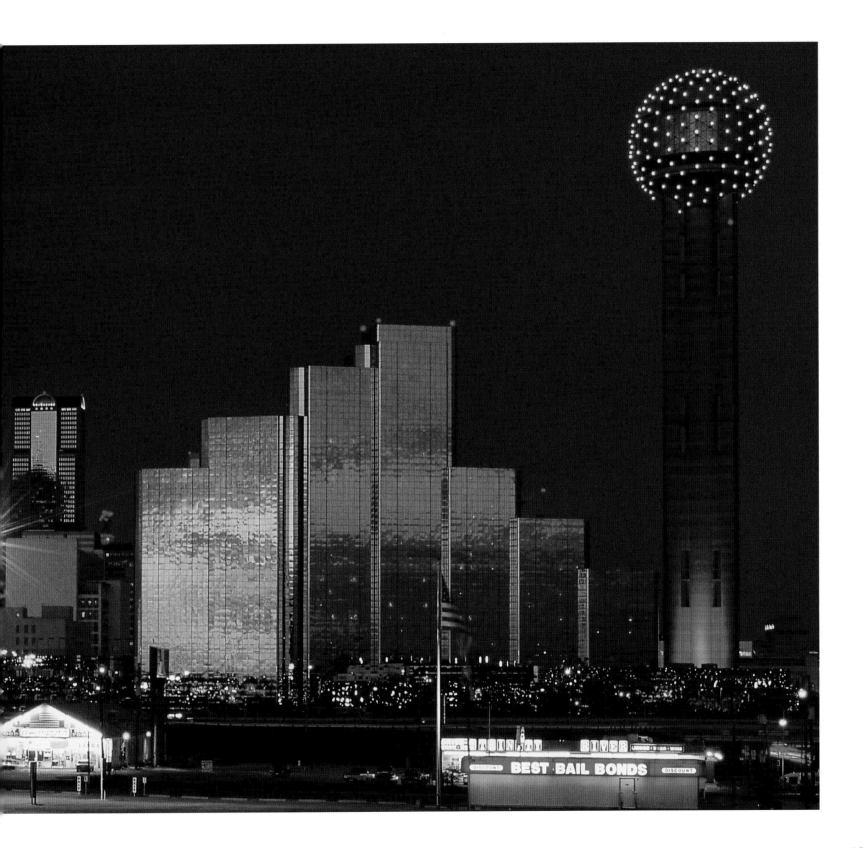

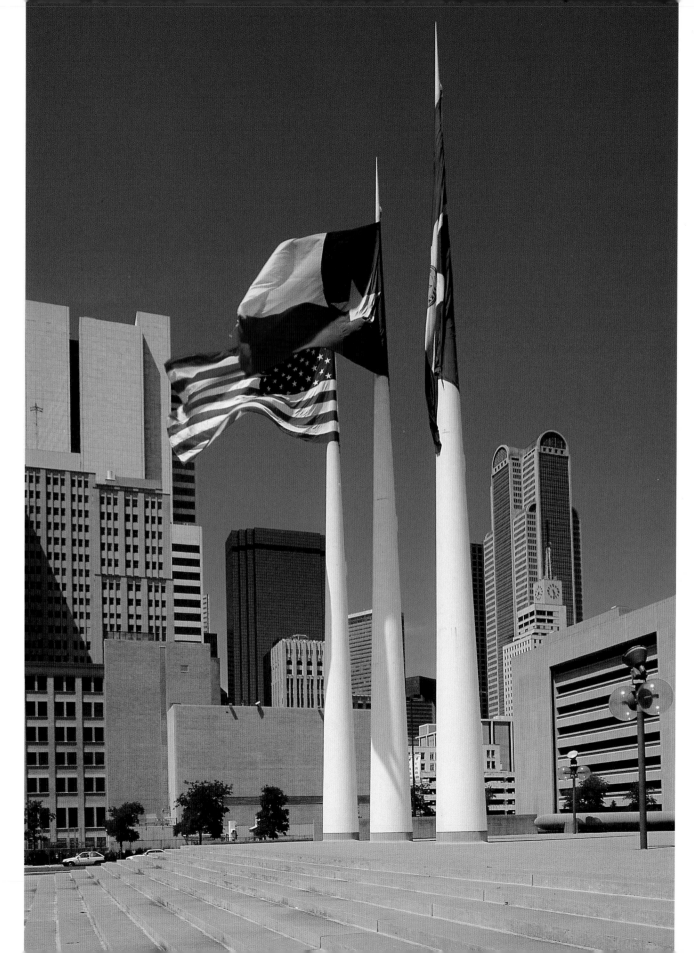

John Neely Bryan, owner of a local trading post, planned the city of Dallas in the 1840s. The community grew quickly when two railways arrived in the 1870s. Dallas is now the nation's seventh largest city.

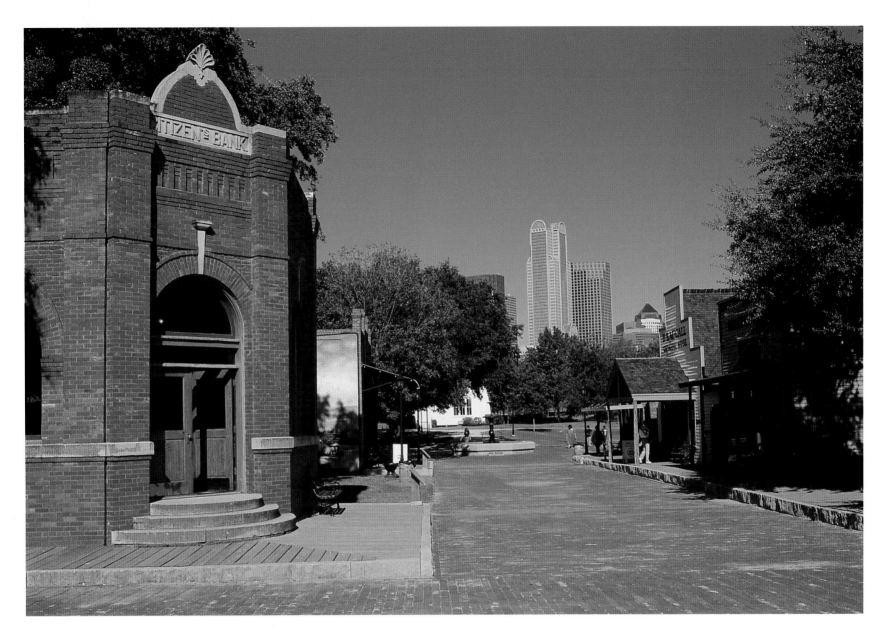

Offering a glimpse of turn-of-the-century Dallas, Old City Park Historic Village includes a bank, a general store, a blacksmith's, a printing shop, and a pottery studio.

Combining 25 acres of exquisite ornamental gardens with more than 40 acres of natural forest, the Dallas Arboretum and Botanical Garden is a tranquil refuge just steps away from the bustle of downtown. More than 200,000 bulbs bloom here each spring.

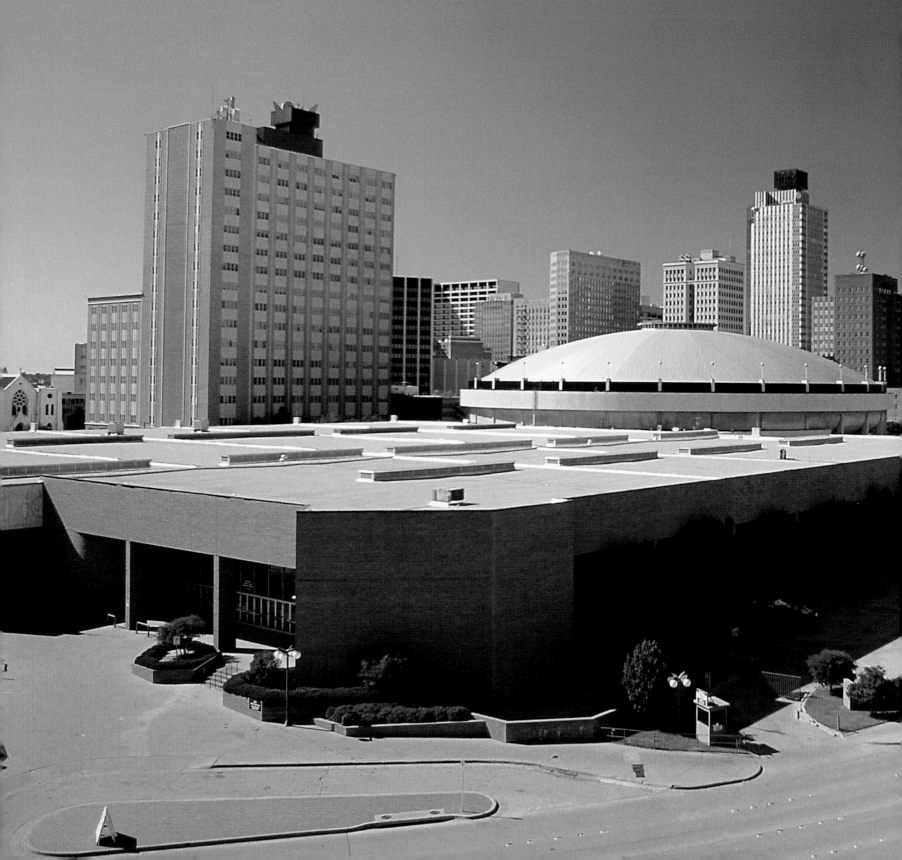

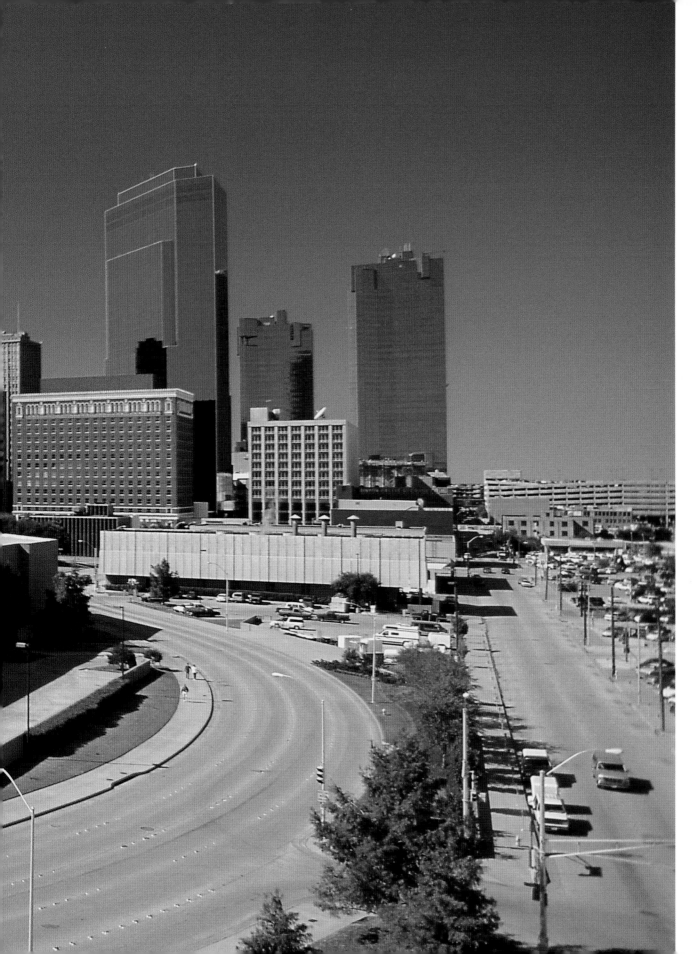

When Fort Worth was established as a military post in 1849, it was named after Major-General William Jenkins Worth, then head of the army in Texas.

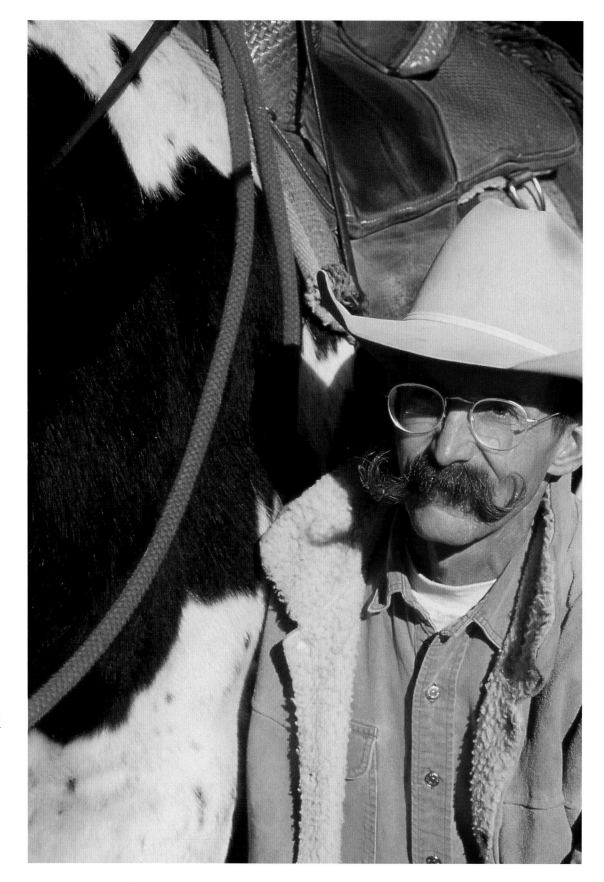

In the 1870s and '80s, ranchers drove millions of cattle north, to better markets. Fort Worth was a major stop on one of the routes, a place where cowboys could rest on the journey north and celebrate on the way back.

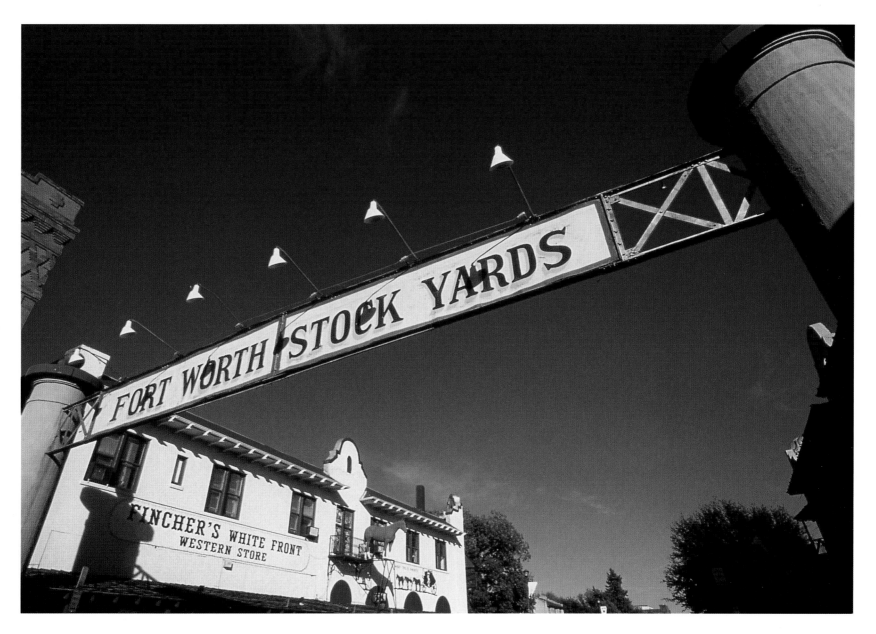

At one time, Fort Worth was home to more cows than people. Visitors relive these Wild West days in the Stockyards National Historic District. An 1896 steam engine offers tours around the area while shops offer western items from felt hats to belt buckles.

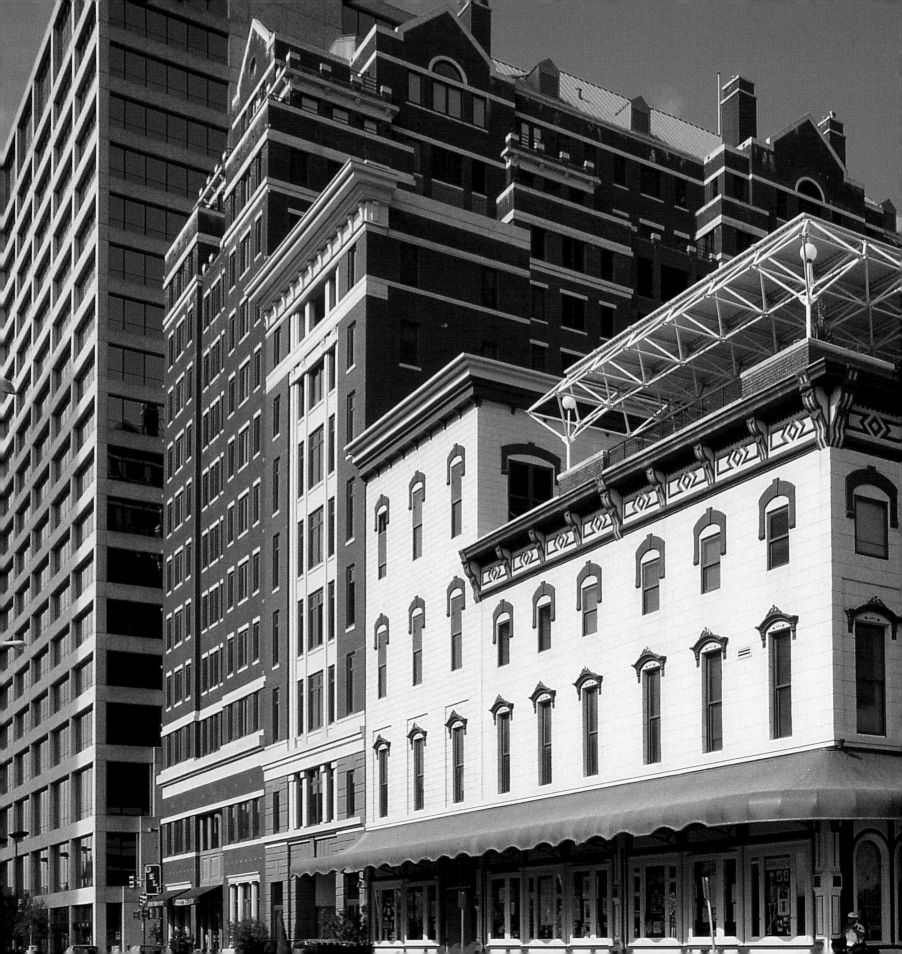

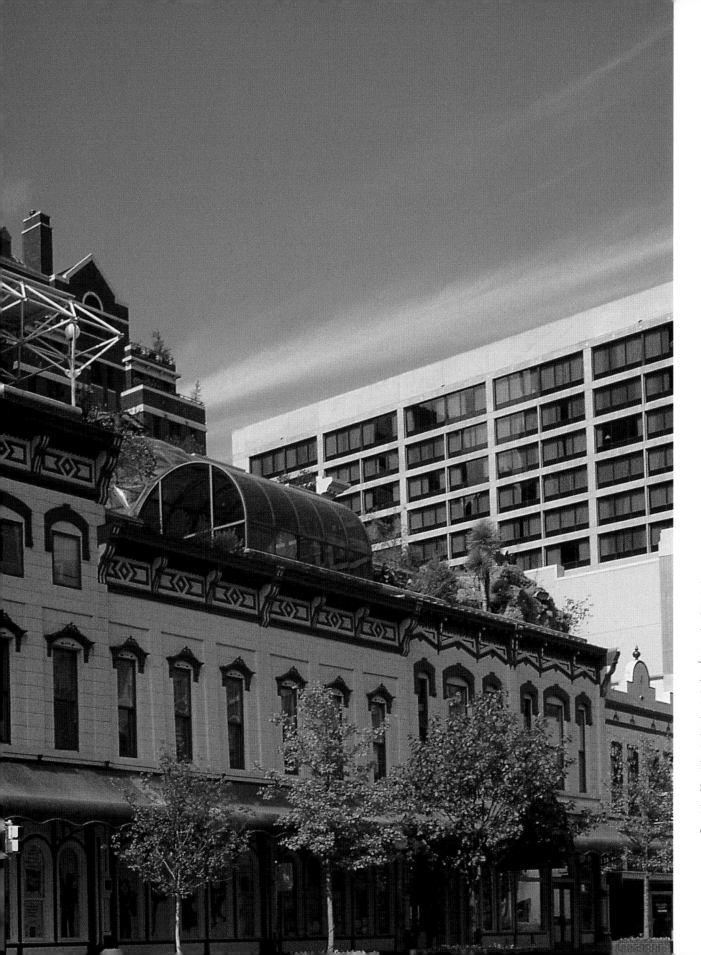

Fort Worth's Sundance Square was awarded the James C. Howland Award for Urban Enrichment. The pedestrian district, known for its specialty shops and safe streets, combines residential and commercial suites.

69

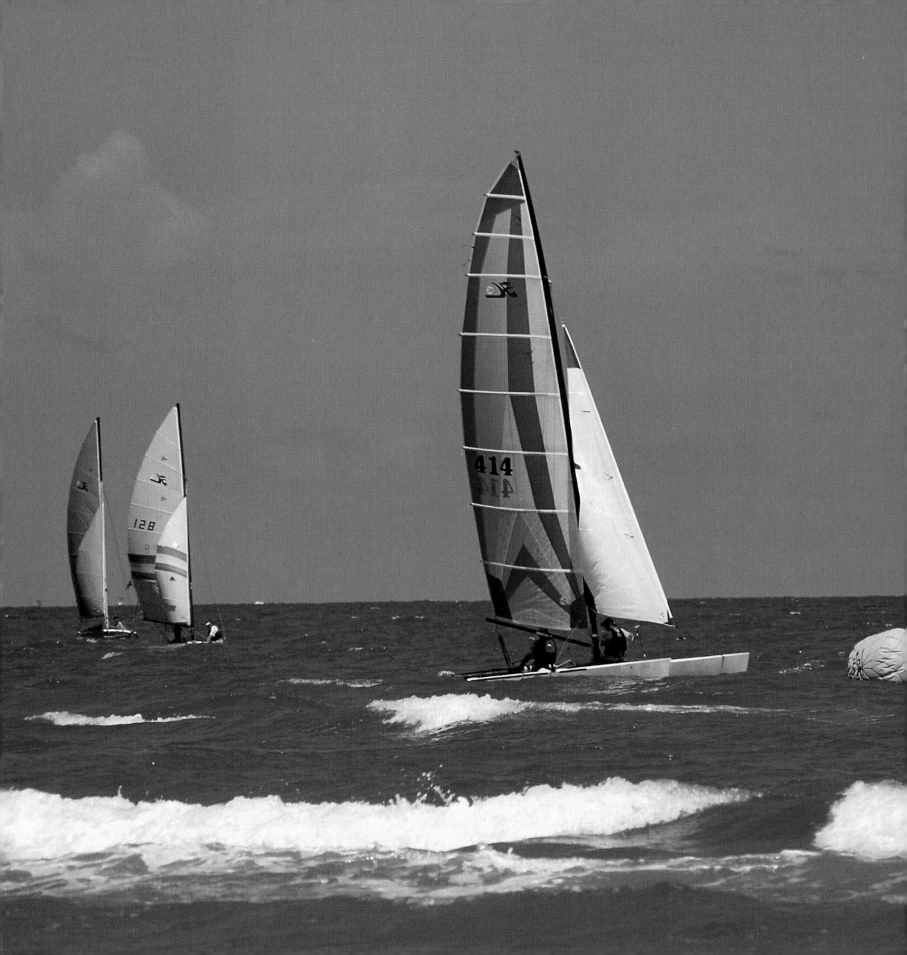

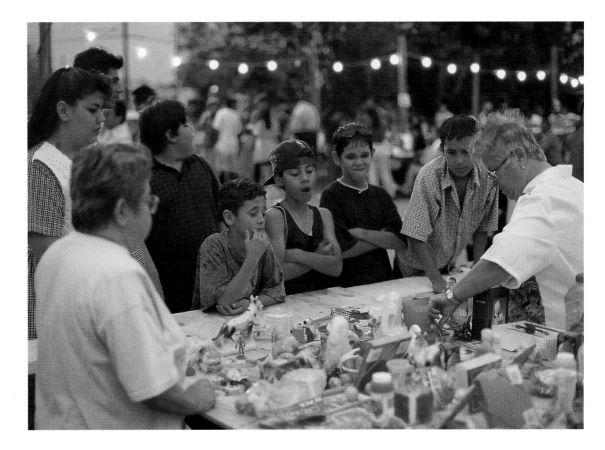

Local children take part in May Day festivities in Roma. Founded in the 18th century, this town was once a major port on the Rio Grande. Several organizations have cooperated to protect Roma's historic sites.

Part tranquil fishing village and part resort destination,
Port Aransas is a wonderful place to spot dolphins
along the shore, sunbathe on a long stretch of sand,
or race catamarans through the waves of the Gulf.

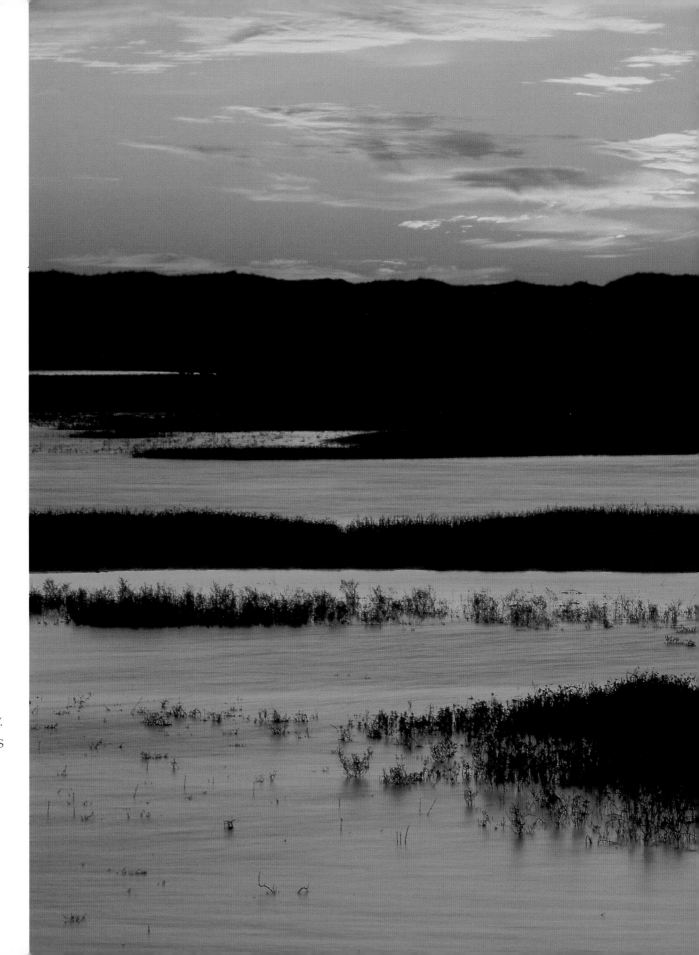

Padre Island National Seashore protects 80 miles of pristine shoreline—one of the longest undeveloped seashores in the country. The island, 113 miles long, is the largest of a string of barrier islands along the Gulf Coast.

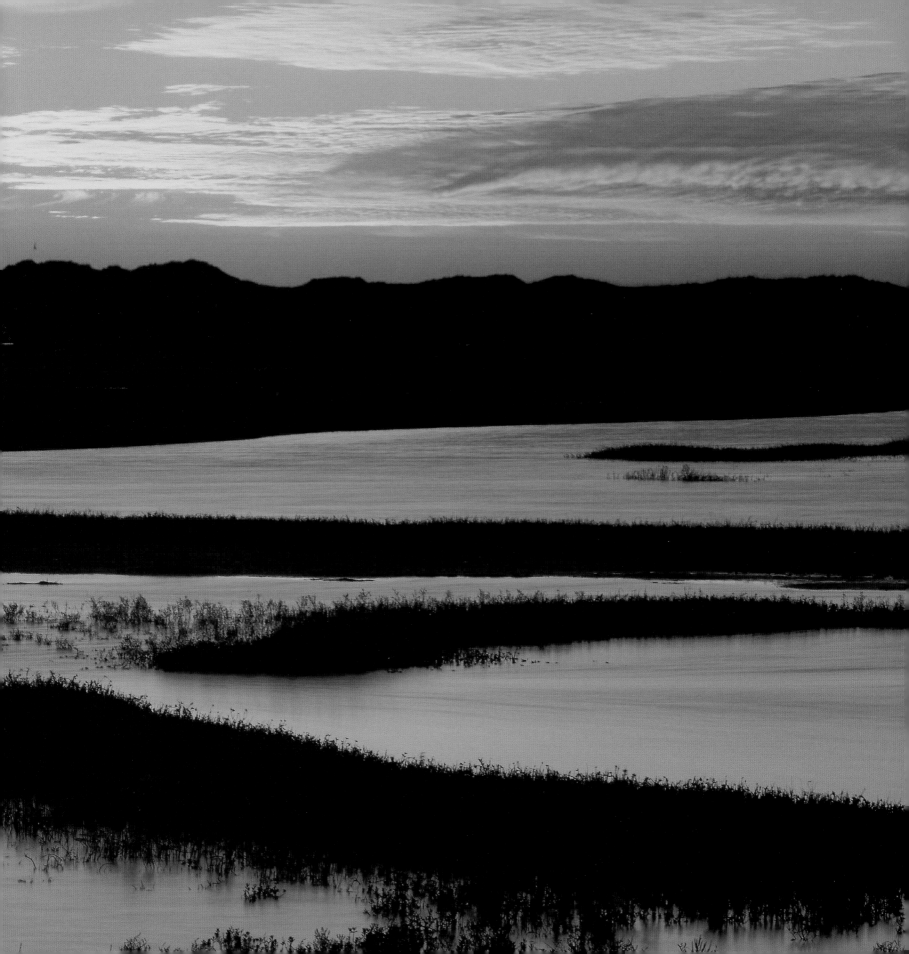

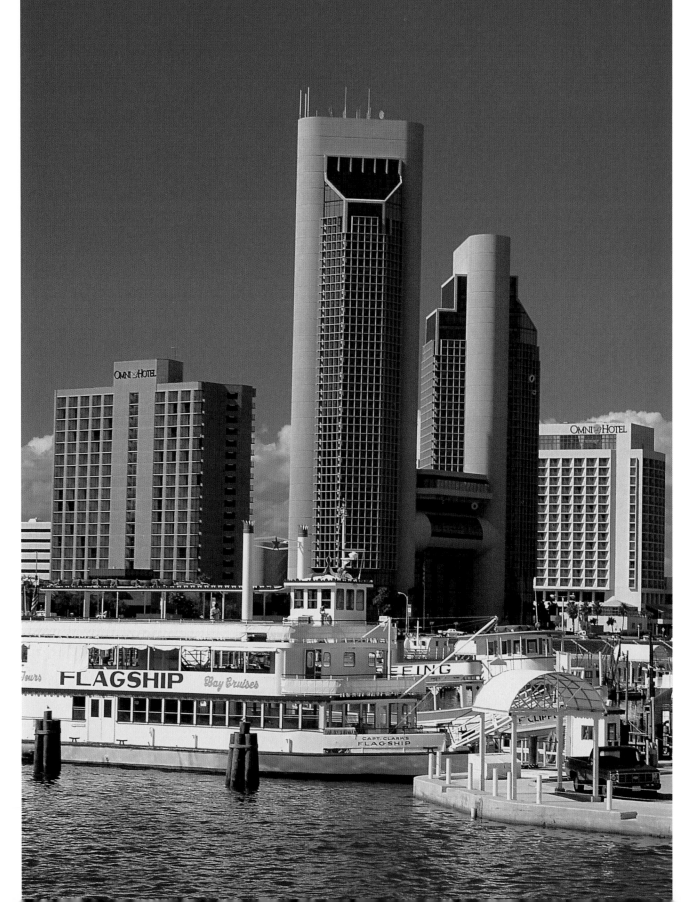

Residents of Corpus Christi don't have to go far to escape the bustle of the city. A short stroll from downtown takes them to the marina and they can be sailing on the bay within an hour. As well as being the perfect place for pleasure boating, Corpus Christi is the state's deepest port.

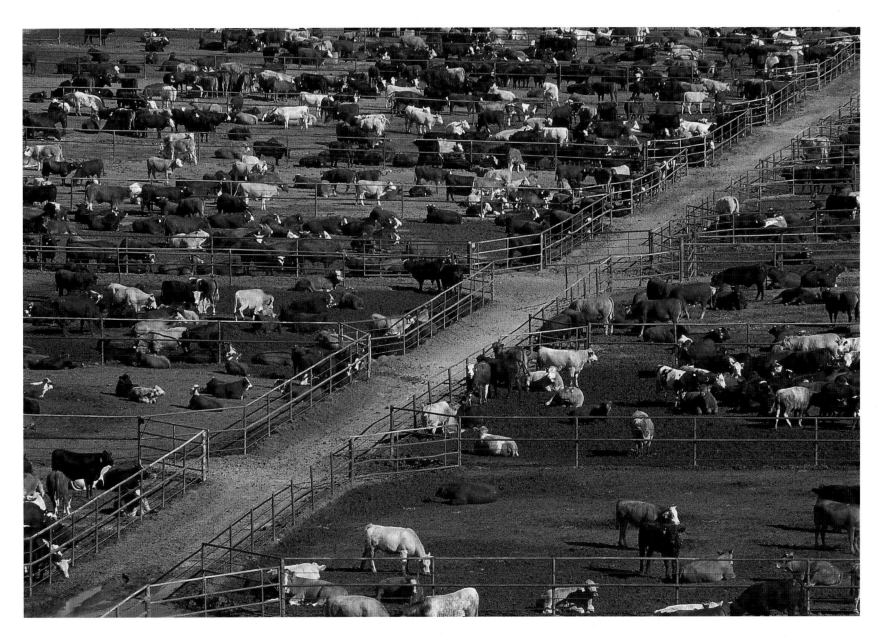

Texas leads the nation in the production of cattle, raising about 14 million head in total. The town of Wheeler is an agricultural center and home to several large cattle feedlots such as this one.

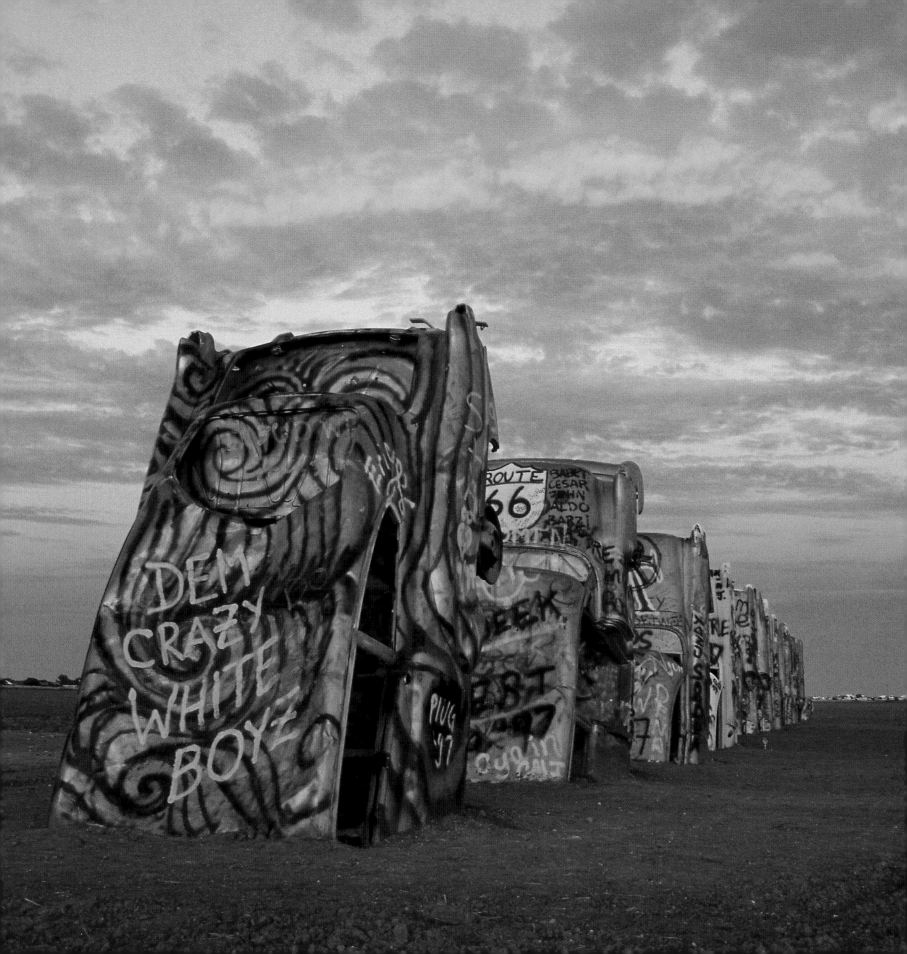

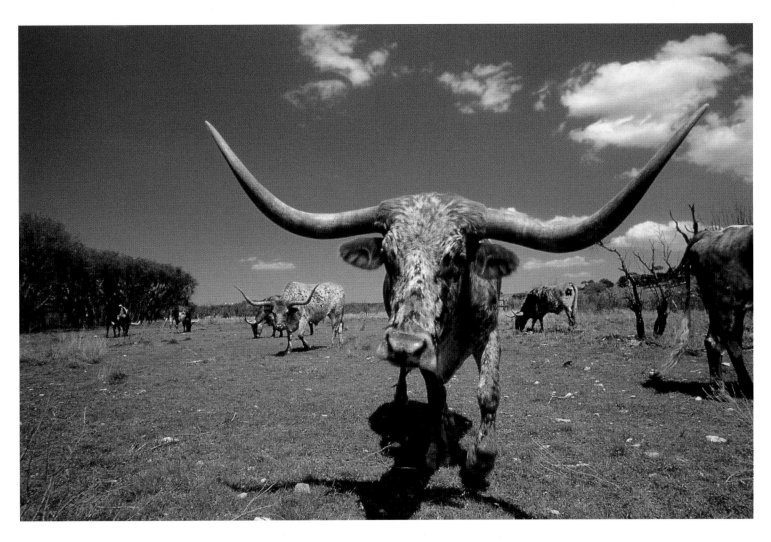

A local ranch resident poses for the camera. The Texas Panhandle is steeped in the traditions of the Old West, combined with the commercial agricultural operations of today.

Called "the hood ornament of Route 66," Cadillac Ranch consists of 10 of the famous finned cars planted amidst the wheat fields near Amarillo. The sculpture is owned by local collector Stanley Marsh III.

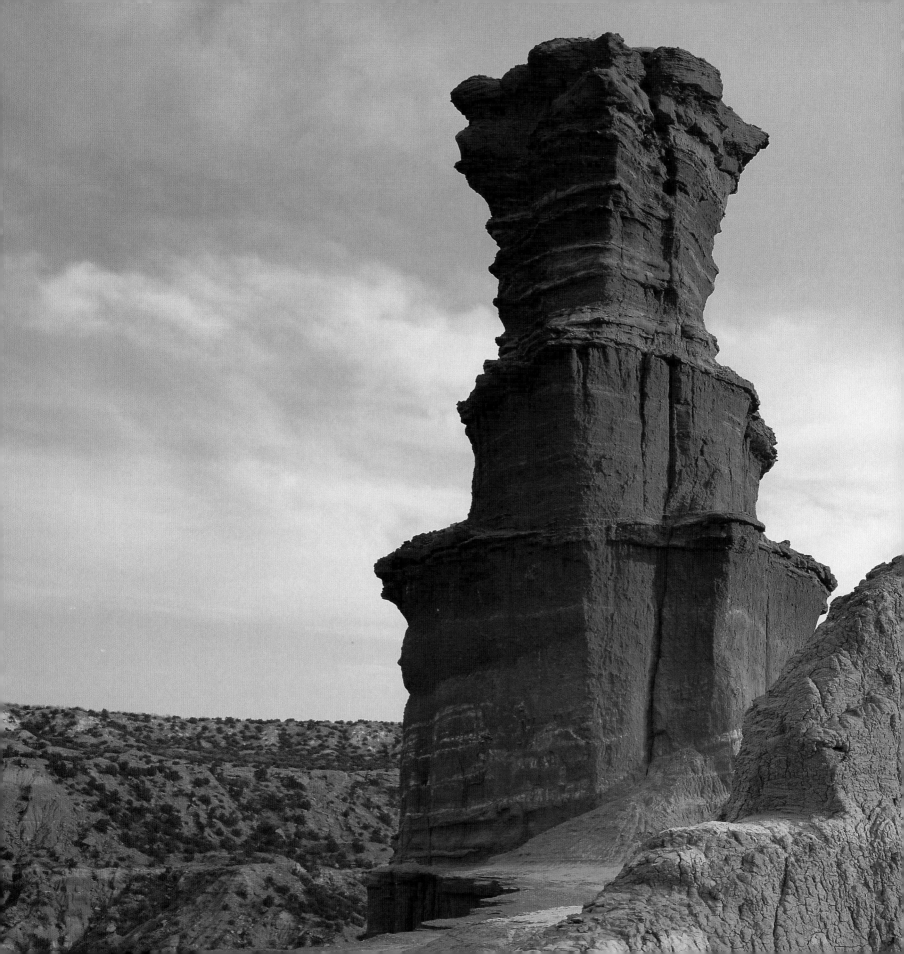

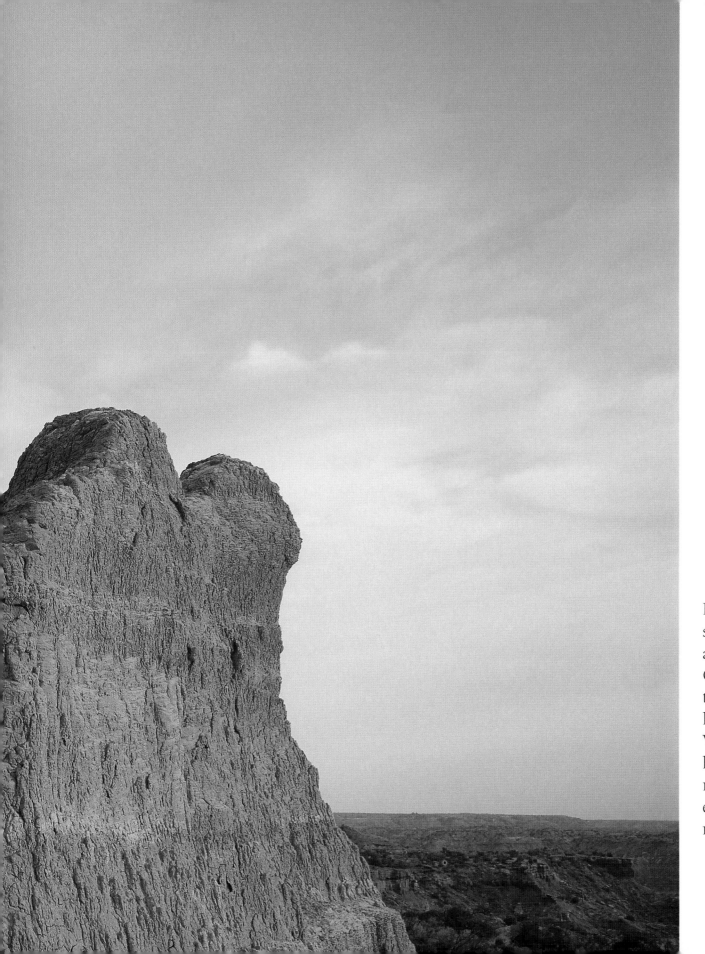

Erosion has had spectacular effects at Palo Duro Canyon State Park, the nation's second largest canyon. Wind and water have created strange rock formations, and exposed rocks 200 million years old.

Fort Bliss, a 19th-century U.S. Army post, is now home to a military defense and training center. The Air Defense Artillery Museum on the grounds allows visitors a glimpse of weapons and tactics throughout history.

OPPOSITE—
Built in 1854, Fort Davis was designed to protect travellers along the San Antonio–El Paso Road. The military left the settlement in 1891 and the 460-acre area is now a national historic site. It is one of the best preserved forts in the state.

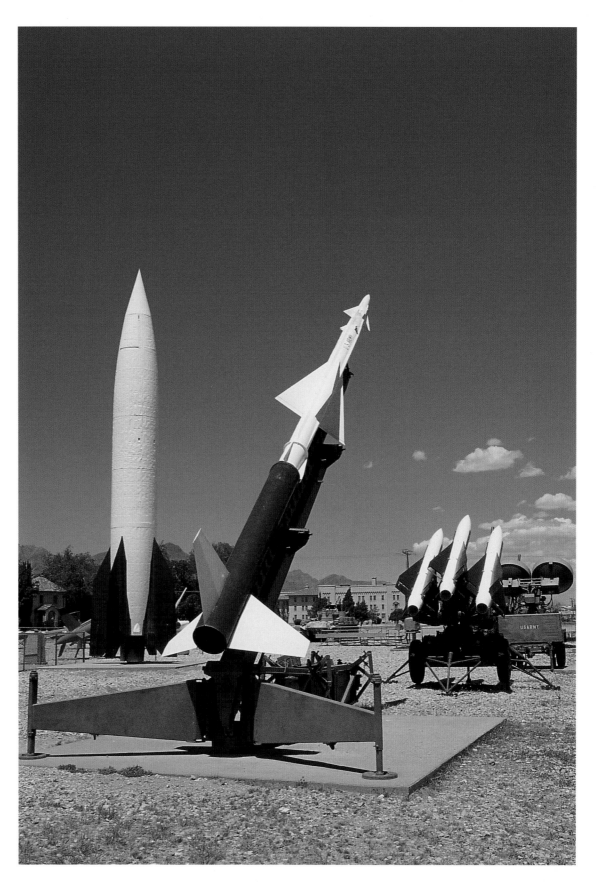

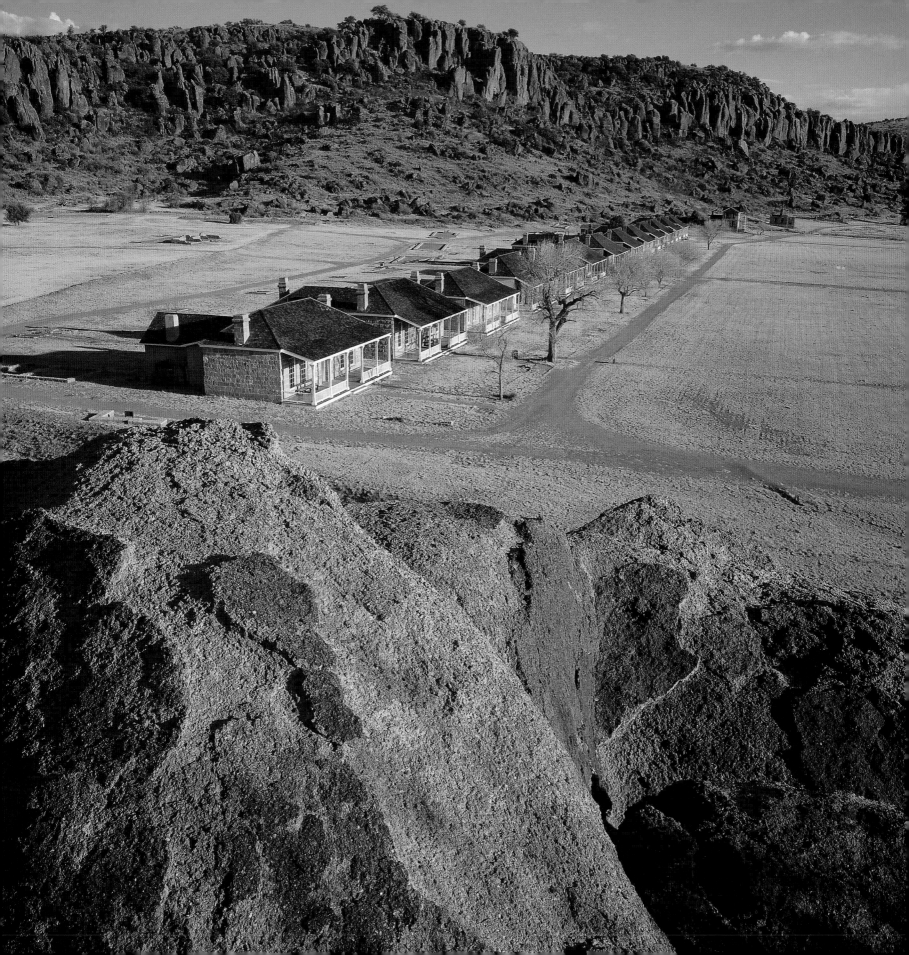

El Paso is 3,760 feet above sea level, in a mountain pass that gives the city its name. This is America's largest border community and is adjacent to the Mexican city of Ciudad Juárez.

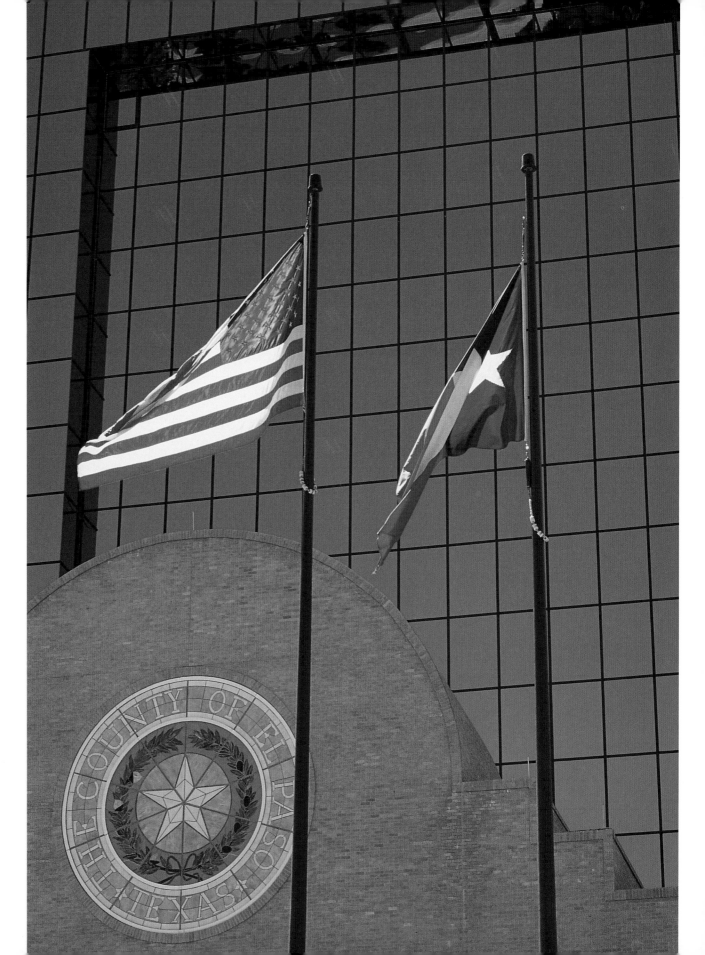

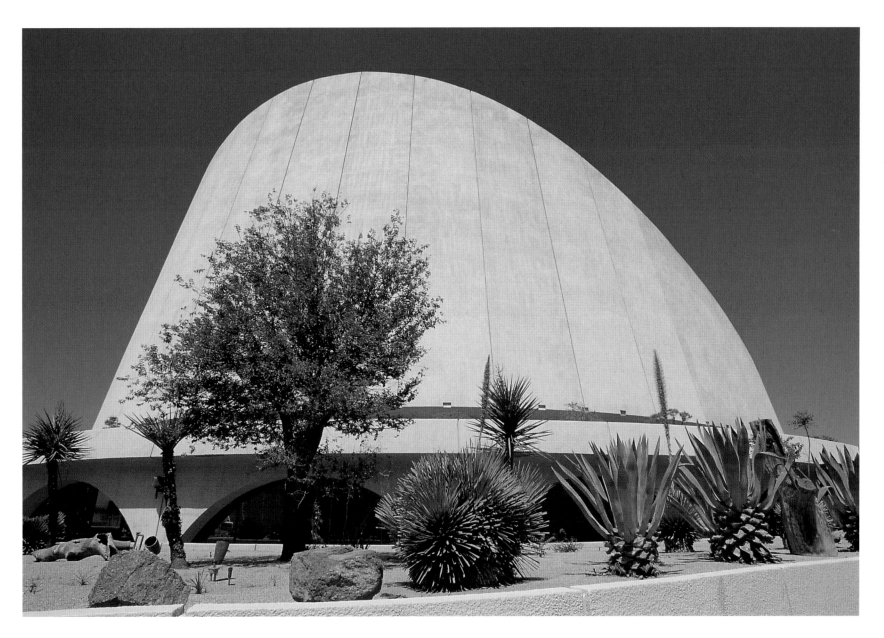

El Paso's small Americana Museum offers a unique look at the history and culture of Native American groups. Displays include an impressive array of traditional pottery.

Much of the land that forms Guadalupe Mountains National Park was donated by ranchers. About 47,000 acres within the preserve is now a designated wilderness area.

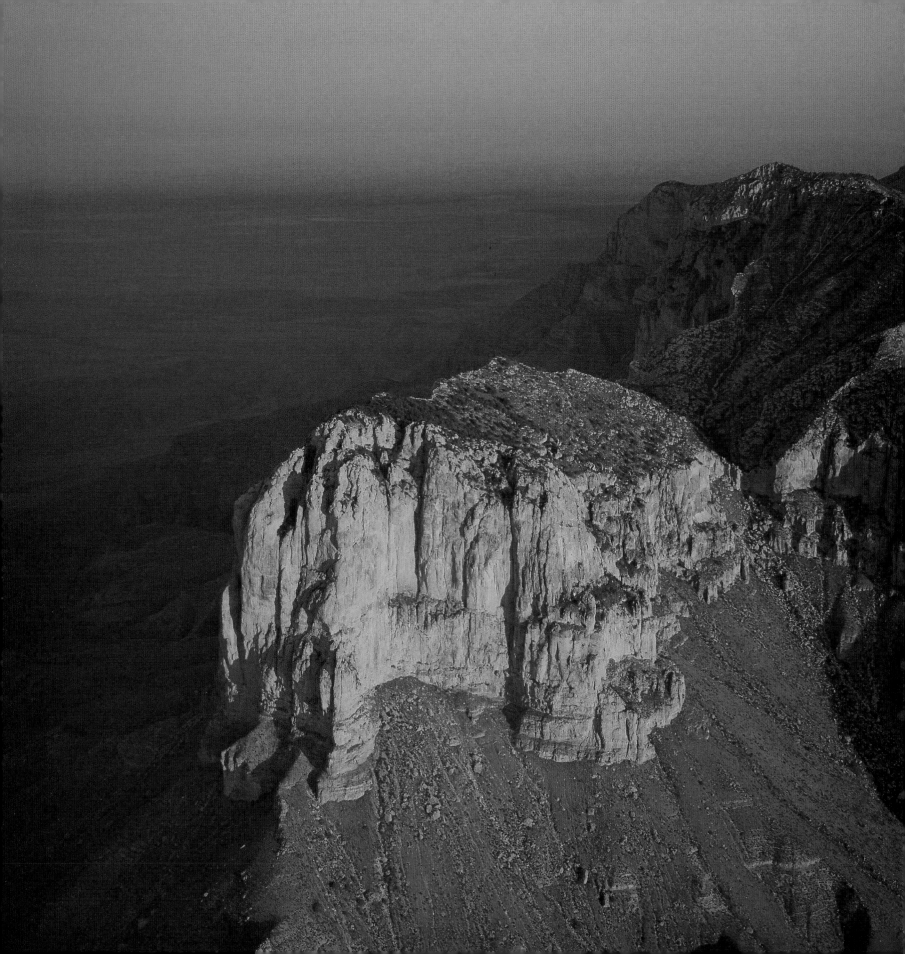

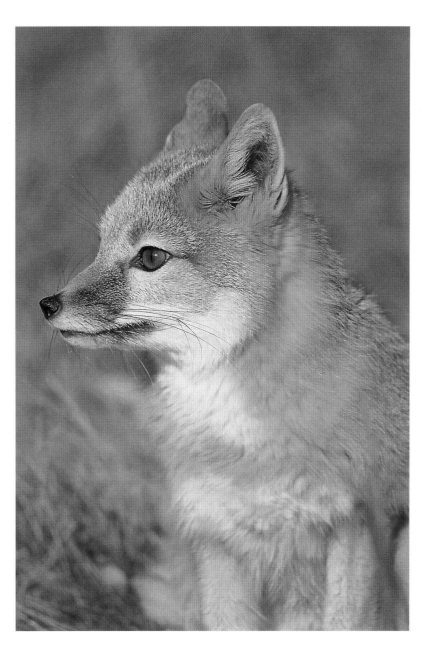

About the size of a house cat, the swift fox can achieve speeds of 25 miles per hour—thus its name. The fox preys on rodents, rabbits, birds, and insects in the state's deserts and grasslands.

El Capitan drops a breathtaking 2,000 feet. This sheer rock face is one of the most recognized landmarks in the Guadalupe Mountains.

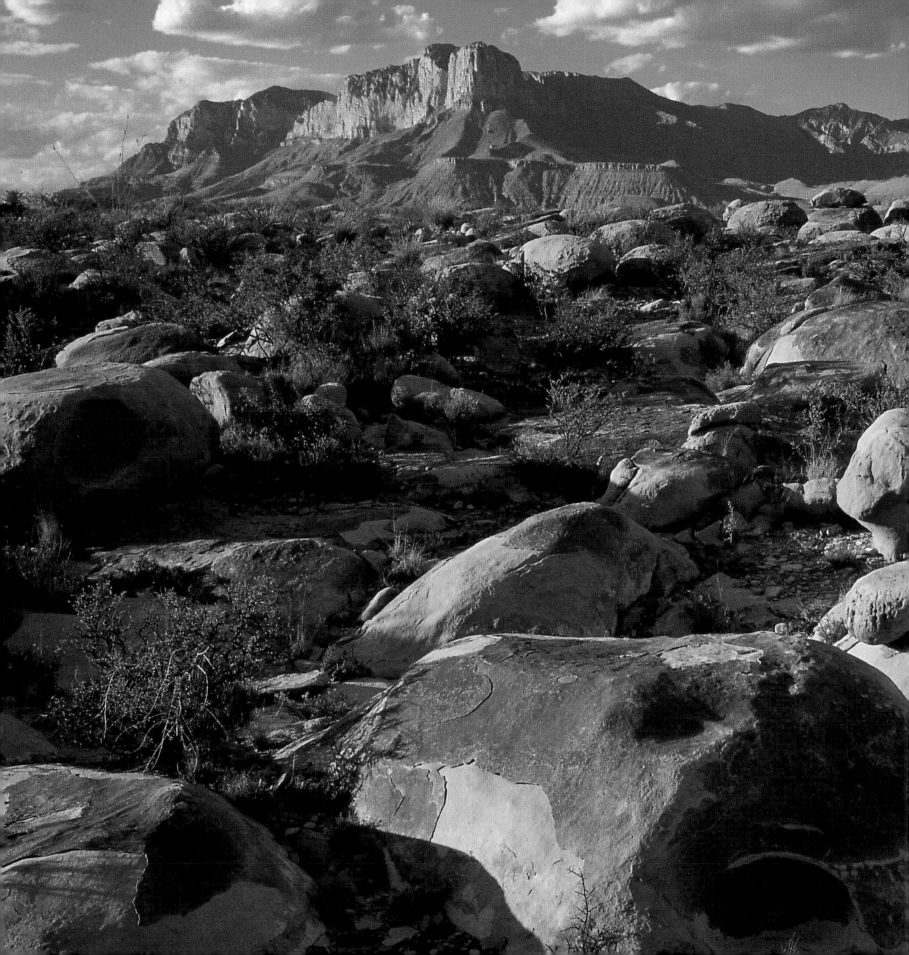

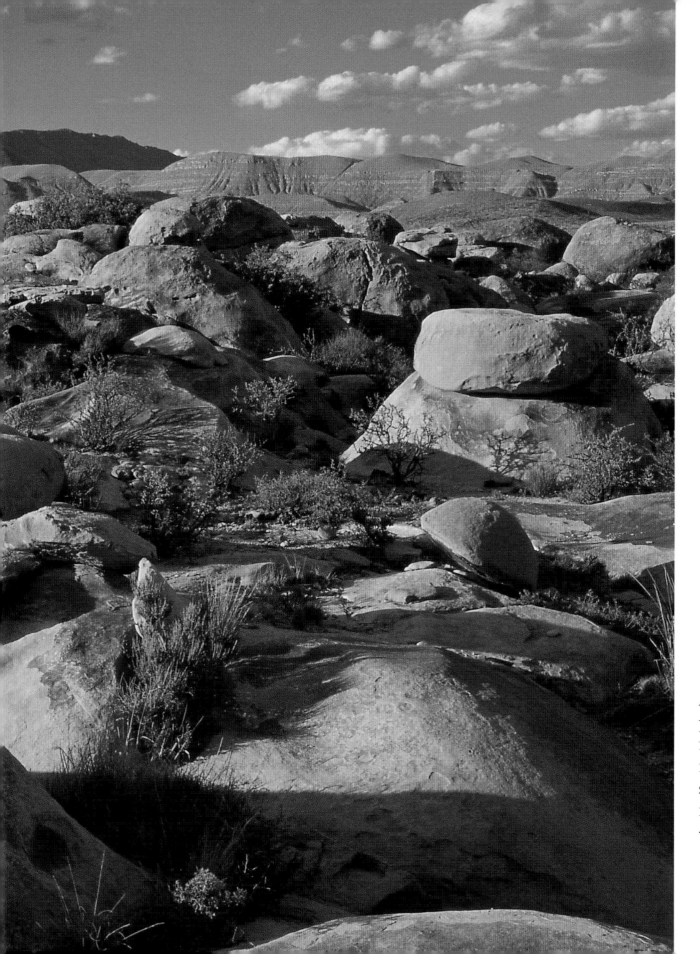

About 250 million years ago, when most of the state was far below an inland sea, these mountains formed part of a 400-mile-long reef.

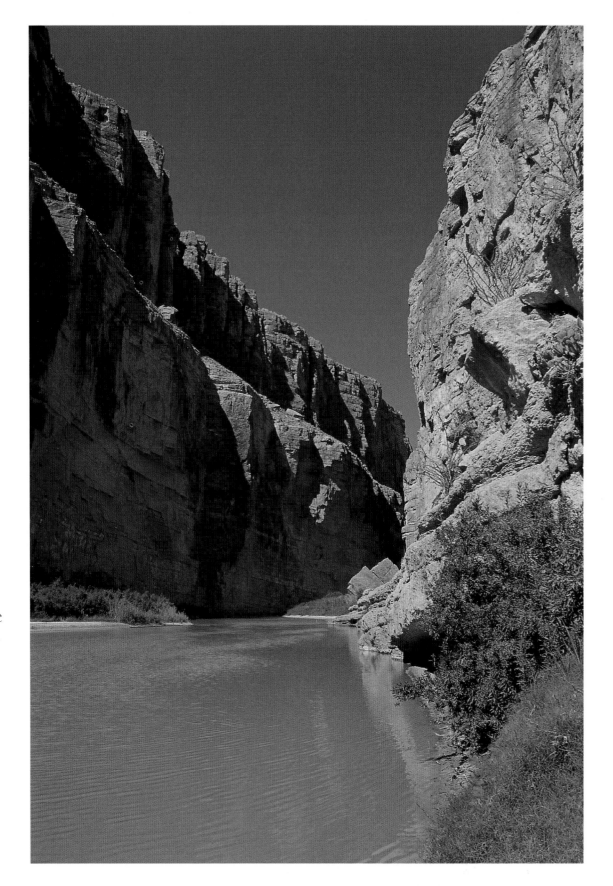

Big Bend Ranch State Natural Area encompasses the rugged beauty of St. Helena Canyon, just one of the natural wonders in the park's 269,713-acre area.

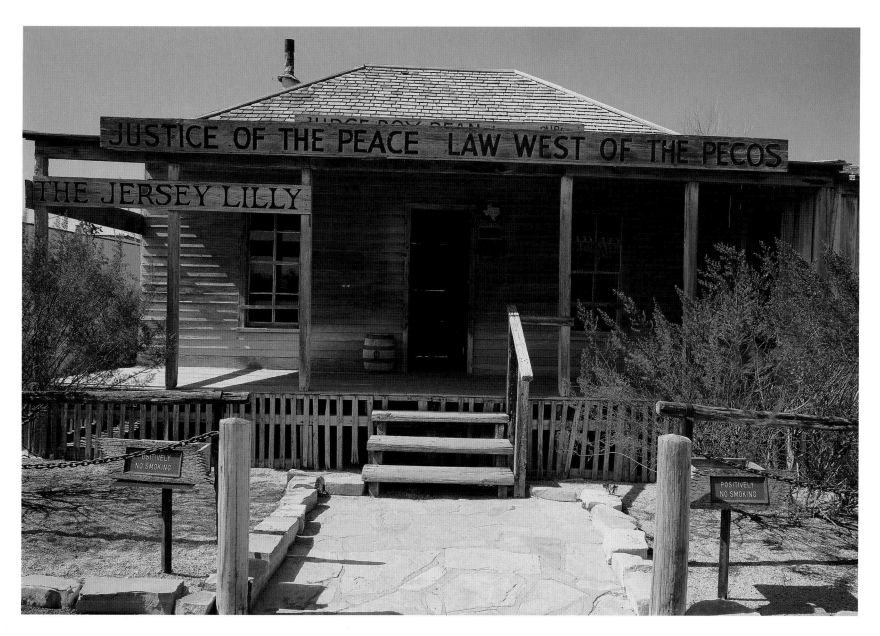

The Jersey Lilly Saloon in Langtry was once the court of Judge Roy Bean, a storekeeper named justice of the peace in 1882. Bean was legendary for creating his own colorful laws and punishments, fining one man $45 and a round of drinks for the jury.

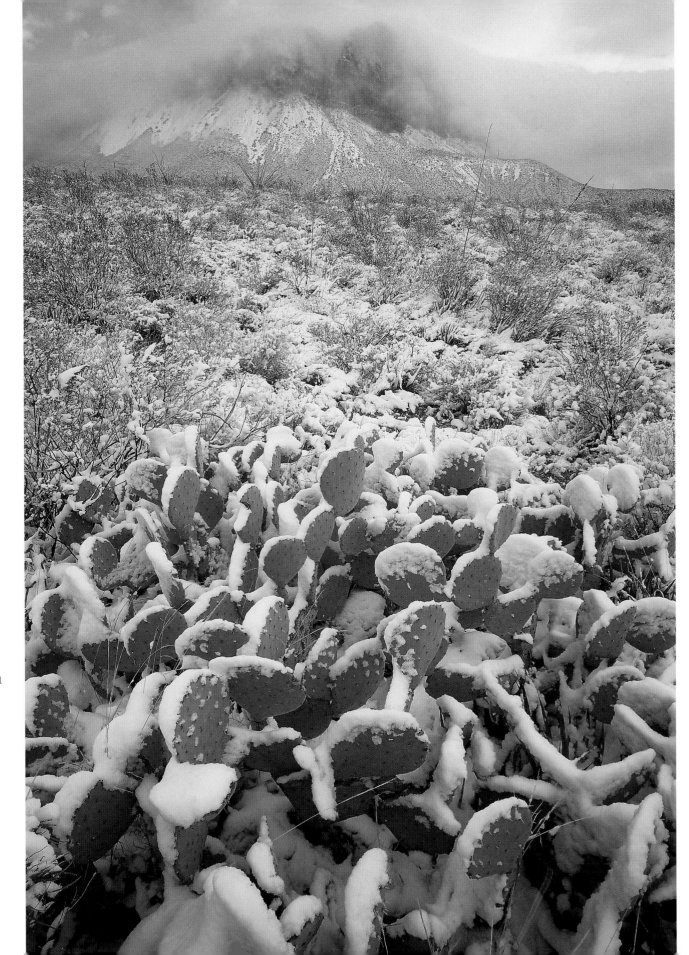

More than 60 forms of cactuses grow within Big Bend National Park, though they look out of place in the snow that has dusted this plateau. The park also supports 75 mammal and 65 reptile and amphibian species.

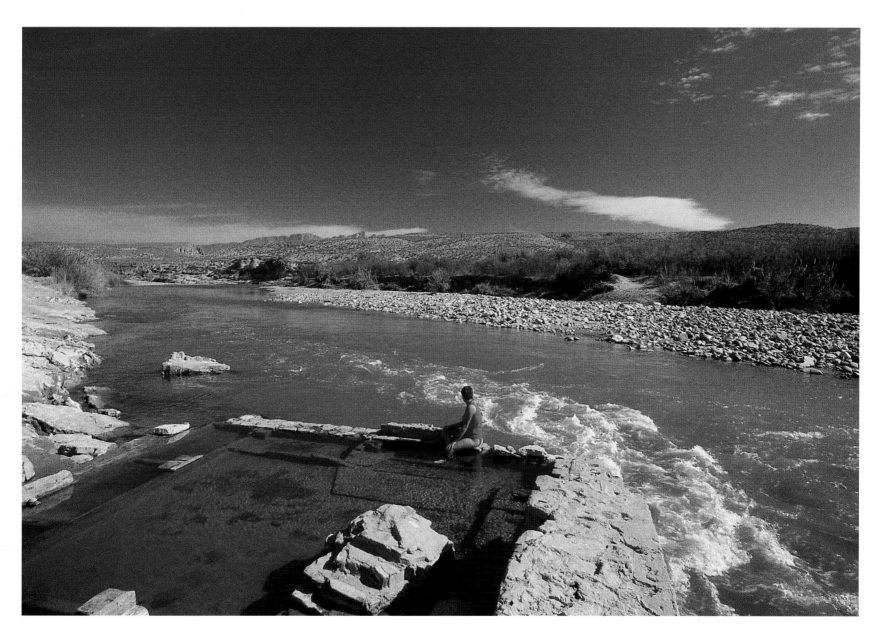

A visitor enjoys natural hot springs along the Rio Grande in Big Bend National Park. The river forms the border between Texas and Mexico, flowing around the wide U-shape that gives this park its name.

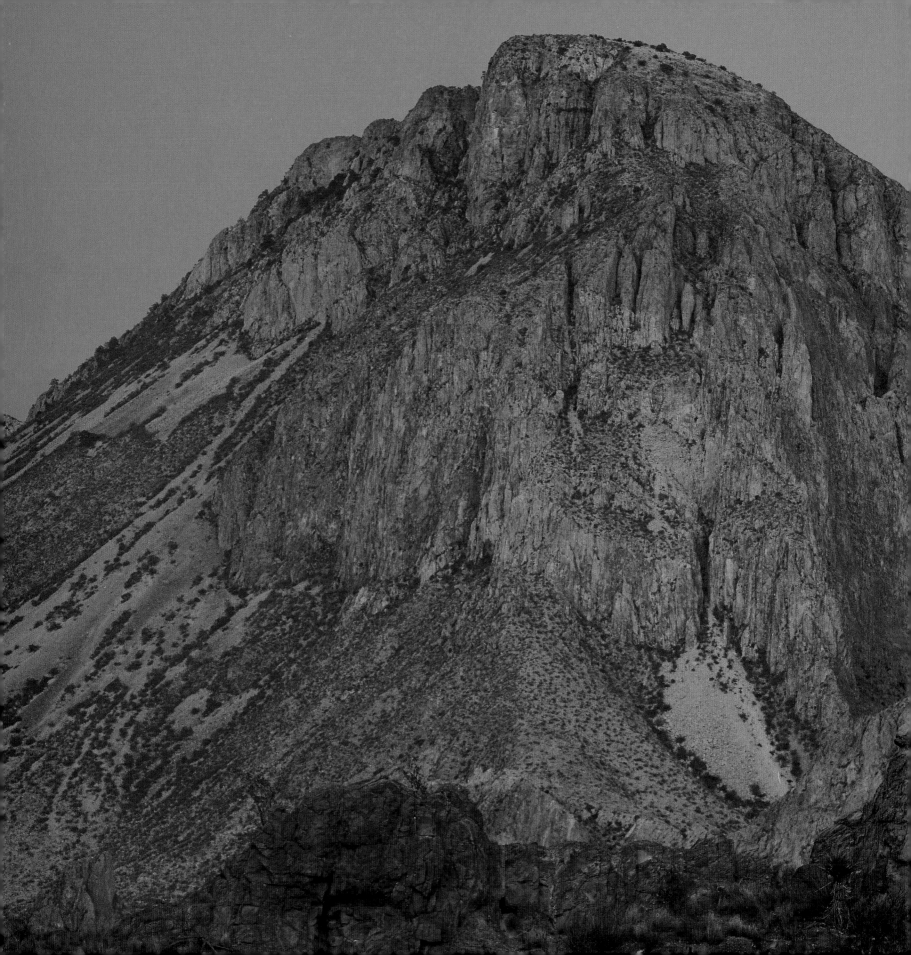

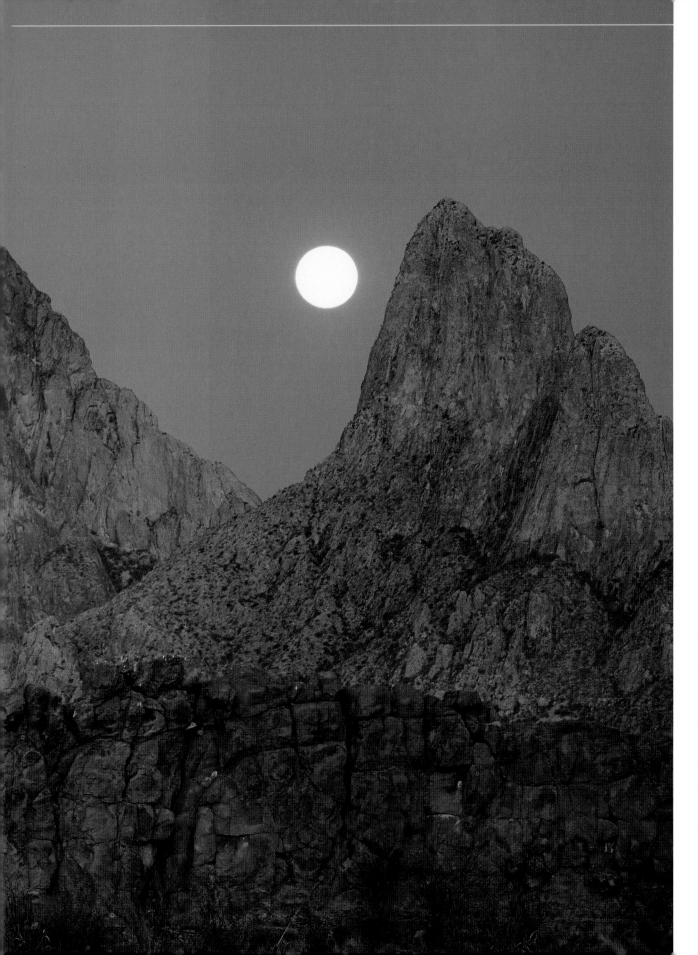

Protecting more than 800,000 acres of pristine Chihuahuan Desert, Big Bend National Park is the only national park in the nation that encompasses an entire mountain range—the Chisos, towering up to 7,800 feet high.

Photo Credits

Tom Till 1, 3, 15, 36–37, 40, 53, 72–73, 78–79, 81, 86, 91, 92, 94–95

Jürgen Vogt 6–7, 10, 11, 12–13, 14, 18–19, 20–21, 22, 27, 46, 48–49, 50, 71, 75, 76, 80, 82, 83, 88–89, 90

Rudi Holnsteiner 8, 9, 16, 23, 24–25, 26, 28–29, 30, 31, 32–33, 34, 35, 52, 54–55, 56, 57, 58–59, 60, 61, 62–63, 68–69, 70

William James Warren / First Light 17

John Shaw / First Light 38–39, 42

Wayne Lynch 41, 43, 87

Chuck O'Rear / First Light 44–45

Trevor Bonderud / First Light 47

D. Boone / First Light 51, 66, 67

Danny Lehman / First Light 64–65, 74, 84–85

G. French / First Light 77

Steve Short 93